ART NOUVEAU

Gabriele Sterner, born in 1946, studied art history, archeology, and philosophy in France and Italy and received her doctorate in 1970. The subject of her dissertation, written under the supervision of Professor Wolfgang Braunfels at the University of Munich, was French art nouveau. She is a free lance contributor to such periodicals as "Neue Sammlung" and "Stuck-Villa," published in Munich. Ms. Sterner has organized numerous exhibitions and prepared catalogs of nineteenth and twentieth century artworks. She has also been responsible for organizing exhibitions of art nouveau and other works of the twenties.

ART NOUVEAU

An Art of Transition—
From Individualism to Mass Society

Author: Gabriele Sterner

Translators: Frederick G. Peters
and
Diana S. Peters

Woodbury, New York / London / Toronto

Front cover illustration: Eugène Grasset, Comb. Ca. 1900.

Back cover illustration: Franz von Stuck, *Susanna at Her Bath*. 1913.

First publication © Copyright 1975, M. DuMont Schauberg Publishers, Cologne.
© Copyright 1977, third edition, DuMont Publishers, Cologne.
All rights for all countries reserved by DuMont Buchverlag GmbH & Co., Kommanditgesell-schaft, Cologne, West Germany. Title of German edition is:

 JUGENDSTIL
 by Gabriele Sterner

First English-language edition 1982 by Barron's Educational Series, Inc.

All inquiries should be addressed to:
Barron's Educational Series, Inc.
113 Crossways Park Drive
Woodbury, New York 11797

Library of Congress Catalog Card No. 79-17025

International Standard Book No. 0-8120-2105-3

Library of Congress Cataloging in Publication Data

Sterner, Gabriele, 1946-
 Art nouveau.

 Translation of Jugendstil.
 Bibliography: p. 170
 Includes index.
 1. Art nouveau. 2. Art, Modern—19th century.
I. Title.
N6465.A7S7413 709'.04 79-17025
ISBN 0-8120-2105-3

PRINTED IN HONG KONG
23456 041 987654321

Contents

N
6465
A7
S7413

Preface.. 6

Stylistic Analysis: Entrances to the Paris Métro.................... 9

The Problematic Aspects of Art Nouveau: Theory and
Practice as Exemplified by Henry van de Velde.................. 27

The Schools, Communal Workshops,
and Centers of Art Nouveau...38

 Nancy.. 41

 Paris.. 46

 Brussels...76

 Barcelona.. 87

 London... 92

 Glasgow.. 98

 Chicago and New York....................................... 105

 Vienna..106

 Munich.. 119

 Darmstadt... 135

 The Netherlands, Finland, and Norway....................... 139

Painting and Sculpture at the Turn of the Century and
Their Relationship to Art Nouveau............................... 144

Art Nouveau Glass:
One of the Most Remarkable Phenomena of the
Movement..149

Conclusion... 165

The Most Important Art Nouveau Architects and
Their Principal Works.. 166

Bibliography... 170

List of Illustrations... 174

Photographic Credits.. 181

Index.. 183

Preface

The term "art nouveau" designates an epoch in art history that extended over a period of fifteen years, beginning in 1890 and ending shortly after the turn of the century. After a long period of neglect and disregard, art nouveau again became the object of extremely lively interest only some twenty years ago. There are several reasons why an objective evaluation of this style was so long delayed. First, a certain distance in time was necessary to let critics put into perspective the exaggerations and abuses admittedly characterizing some of these works. Second, during the period between the two World Wars, the political situation was such that it would simply have been too daring to write about this "decadent" style. The massive production of handicrafts that began around 1900 and the immediate popularity of the new style led to a superabundance of inferior products. These works were held up as examples of an artistic sensibility that was actually, at its best, extremely demanding and highly developed. It was very difficult for critics to free themselves of the dead weight of these inferior examples. Nevertheless, it was absolutely necessary to eliminate this ballast, so that the concepts of creativity underlying art nouveau might be understood and the movement evaluated on the basis of works of genuine quality. As of this writing, this process of sorting out has been completed and the boundaries have been drawn; thus a critical assessment may now be undertaken. Nevertheless, various contradictions in the movement have not yet been resolved, for art nouveau gives rise to the most diverse

responses. The emphasis that each critic chooses to place upon this or that aspect of a highly complex art form necessarily leads to highly subjective conclusions.

Art nouveau has already been subjected to considerable critical study. The question nevertheless remains as to whether such investigations have led to any significant conclusions. The increasing popularity of this style in the 1950s led to indiscriminate collecting, which eventually reached unparalleled proportions. Vases, dishes, and furniture that showed nothing more than a single decorative line or a stylized curve were regarded as beautiful examples of a style that dominated the art world around 1900. Thus art nouveau became fashionable not only in art historical circles but in cultural life as well. This curious phenomenon was examined by later researchers, as was the art form that generated such amazing popularity. Interesting insights evolved that superseded the emotional criticism of the turn of the century as well as that of the prewar period; some of these insights are still valid today. On the other hand, it is necessary to reject such condescending epithets as "a witches' brew of ornamentalism" or "bookworm passion." Similarly, just as it is necessary to put the movement's excesses into proper perspective, it is also important not to overestimate the philosophical intentions of art nouveau. One of the most important tasks facing art historians and critics was to uncover the historical significance of art nouveau which, as a linear form, seemed to be heading toward constantly increasing abstraction. Obviously, this task generated a number of different and conflicting opinions. Several defenders of the movement thought they could increase the importance of art nouveau by connecting it with names of artists who should, in fact, not be mentioned at all in this context. Such errors are easily committed when the period being investigated is of such short duration as was that of art nouveau. Nevertheless, it is quite wrong to call figures such as Gauguin, van Gogh, Kandinsky, and Klee art nouveau painters. The mere fact that these painters once briefly admired this movement does not justify their inclusion in it. With well-intentioned zeal, critics have also hinted at connections between art nouveau and the works of Freud, Marx, Wagner, and Schopenhauer. Although the influence of these men was evident in all the intellectual currents of the turn of the century, they had no substantive effect on art nouveau.

The only way to resolve this critical dilemma is to consider the objects themselves. Art nouveau has a definite "snob appeal." As Julius Meier-Graefe, one of the movement's most ardent defenders, said with pointed candor: "It was nonsense, but divine nonsense, and there's not a soul who regrets having been part of it." Since this period represents one of the most complex eras in the intellectual development of the last hundred years, an objective approach is of paramount importance. In this regard, museums have taken the lead by arranging exhibits that have stimulated critical discussion. The reassessment of art nouveau has been undertaken with a passion characteristic of the explorer. As a result, unpretentious objects, indeed mere handicrafts, have been euphorically classified among genuinely valuable works of art. Thus a comprehensive if concise survey of this artistic movement must set itself the task of objectively illustrating the whole spectrum of works in which this expansive artistic program—a movement straddling the past and the future—found realization.

Stylistic Analysis:
Entrances to the Paris Métro

The situation around 1900 becomes clear when we look at one of the Paris métro entrances designed and constructed by Hector Guimard. The commission of this project was totally unprecedented—an artist had been asked to create a work of art for the mass transportation system and to place it in the middle of a public thoroughfare. Guimard's entrances were to provide an artistic framework, as it were, for a technological achievement that was oriented toward serving the masses. Obviously, it was necessary to find a design that would appeal to the masses. Yet Guimard selected stylistic elements that also proved able to satisfy the artistic tastes of the connoisseur.

A photograph of a Paris métro station (fig. 1) taken around the year 1900 is extremely revealing. This picture enables us to see at once the novelty of the new ideas that were sweeping through the art world of the period. Like strange foreign bodies, new forms that have been shaped entirely in accordance with new creative principles emerge before us, eluding definition by traditional concepts of art. In the photo, the classical façade of the Louvre towers over the square. This façade possesses all the features of classical French architecture, which dominated all building style well into the nineteenth century and gave Paris its unique character. This style is "cool," grand, and oriented toward a stately appearance. In its use of space, French architecture was not concerned with interiors but rather with the relationship between

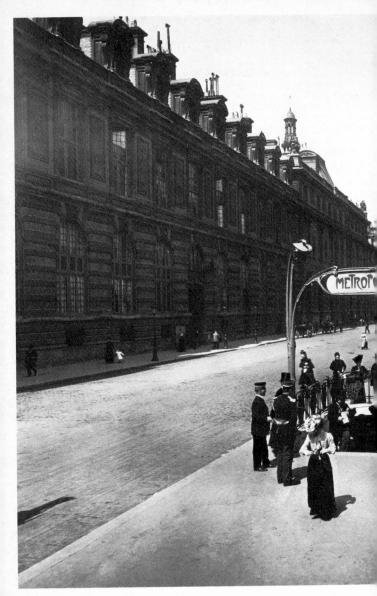

1 Hector Guimard, Métro station "Place du Palais-Royal," Paris. 1899–1900

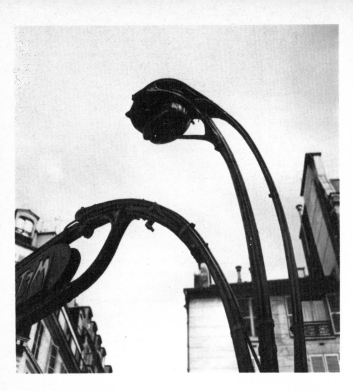

2 Hector Guimard, "Lampes tulipes" of a Métro station, Paris. 1899–1900

the building itself and its external surroundings. And indeed, the Louvre rises majestically above the square, strangely aloof and severe. Its fundamental stylistic features are abstract perfection and the absence of both decoration and color. In contrast to the imposing façade of the Louvre, the figures emerging from the subway, which give life to the scene, seem small and insignificant. Their clothing is dark and severe. The women are tightly corseted. Their full taffeta skirts, which are pleated and ruffled, fall stiffly away from the body and are, in fact, at odds with the body's natural shape. In the middle of this conservative picture, there suddenly appears a pair of lamps rising like strange, exotic plants above the entrance to the subway. Seemingly unburdened by sober thoughts, these lamps soar aloft upon arched stemlike columns and end in

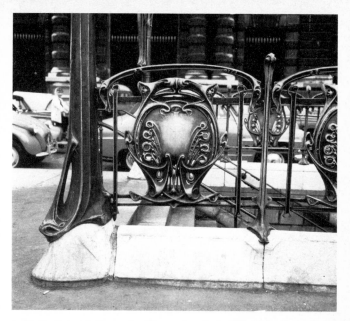

3 Hector Guimard, Ramp of a Métro station, Paris. 1899–1900

globes of light framed by petals suggesting the blossoms of an
orchid (fig. 2). The low side railings (fig. 3) continue and intensify
the lightness and organic flow of their flowerlike crown. The whole
mood of the square is suddenly transformed. Gone are its severity
and bombast, which have yielded to and are now enveloped in an
almost sensual aura. "Art nouveau" has arrived and holds us
spellbound. It is not difficult to recognize its features and to explain
them here.

 The first and most notable aspect is this style's obvious
integration of various artistic disciplines. The entrances to the Paris
métro are genuine hybrids. On the one hand, they cannot be
classified as architecture in the traditional sense; on the other, they
are not purely decorative elements, since they perform a particular
and definite function. Although trained as an architect, Guimard
referred to himself as *l'architect d'art,* an "architect of art." The

unified ornamental ensemble we see in his métro station cannot be defined by traditional art-historical concepts. Guimard's work represents, rather, a "crossbreed of architecture and applied art, sculpture and decoration; it is plastic ornamentation with a practical value" (Schmutzler). Architecture comes to be regarded as sculpture. In art nouveau, painting takes on a spatial dimension and is viewed as an ornamental element within a decorative whole. Applied art becomes alienated from its fundamental purposes and serves as a vehicle for the creation of increasingly ambitious and costly objects. Buildings come to lose their structural significance and take on the smaller proportions of a "jewel case, while the products of applied art become monumentalized and revalued as architecture." Sculpture yields to the artist's decorative intentions; at the same time, functional objects become sculptural works of art. Jewelry is no longer simply an accessory, an array of costly stones that merely testify to their possessor's wealth. Rather, jewelry takes on narrative significance and symbolic content. Printing and book illustration are harmonized with content; indeed, the very covers of a book become a new decorative language intimating what is to come inside. This total reformation was born of an intensive period of searching in which all known models were subject to revaluation. In the end, artists were offered a radically new basis for their creative activities.

This revaluation went hand in hand with criticism of the historicism of the academies. A rebellion against the academic-positivistic approach to the representation of nature had already taken place. Artists who were no longer willing to conform to the rigid demands of the people and institutions that determined artistic taste had made themselves heard in the Salons des Indépendants. The elements comprising the new style began to manifest themselves in the 1880s. At the same time, impressionism found its first opponents; they perceived its speckled and stippled effects of light and shade as being superficial. Throughout the world, artists faithful to their own inner perceptions joined forces in rejecting the academic formalism of official art. Under various names, these groups strove to articulate creative principles that would coincide with individual feelings and attitudes. Many of these artists were strongly influenced by literature and the symbolist movement. The results of their efforts often appear strange. In any event, the storm against the academies gradually extended to all fields of visual art.

This protest was not a revolution, however. It was, rather, a liberation from historical models that had imprisoned art in a predetermined mold for such a long time. Numerous artistic communities arose, and these were soon to form a network throughout Europe. Admittedly, this was a loosely woven net, one whose threads were spun of many different yarns; yet there remained many common ties to join them together.

In architecture and related disciplines, everything was subject to critical questioning, as is evident from our example of the Paris métro station. (Obviously, structures that remained conventional in principle, boasting merely a few bits of art nouveau ornamentation in place of traditional decoration, do not signify any real change and will not be considered here.) From the inception of the classical period, the fundamental structural principle of architecture was based upon a scheme of weights and balances. Clear ground plans with visible rectilinear demarcations were required. Walls were to be differentiated from columns, false fronts, blind niches, or superstructures, all of which were regarded as supplements to the basic design. In place of these static concepts with prescribed rules for adding decorative elements and other supplementary frills, a dynamic and much simpler form of architecture emerged. Although the new style manifested itself in numerous forms, two basic if somewhat contradictory ideas are clearly recognizable. First, architecture was conceived as a form of plastic art; second, there emerged a principle of design derived from mathematical perception, according to which structures were reduced to their basic forms and then enlivened by cubic, multifaceted ornamental surfaces.

In accordance with these theoretical considerations, artists selected new types of building materials through which to realize their ideas. Glass and iron played the most important role in the architecture of the art nouveau period. Of course, these materials had already come into use forty years earlier, beginning with the Crystal Palace in London (fig. 4), built to house the World's Fair of 1851, and culminating in the Eiffel Tower (fig. 5), built thirty years later to celebrate the World's Fair in Paris. Guimard's entrances to the Paris métro are not masonry portals but rather structures made of cast iron. This was the only material that could be used to produce the slender sinewy columns that support and encase the lamps. Annealed molten iron provided precisely the kind of

15

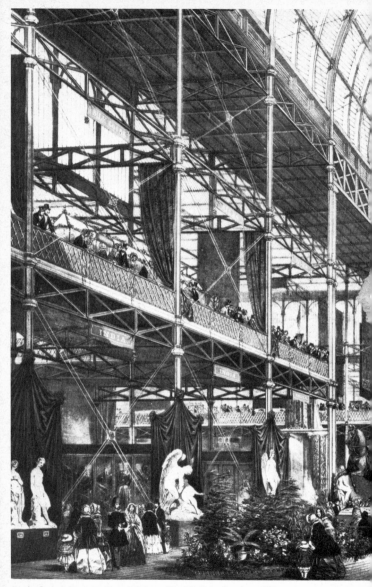

4 Joseph Paxton, Crystal Palace, World's Fair, London. 1851

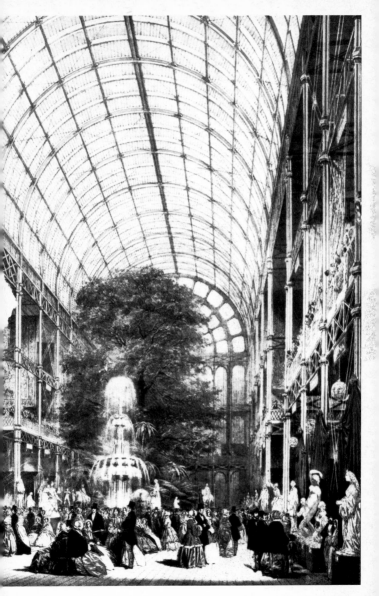

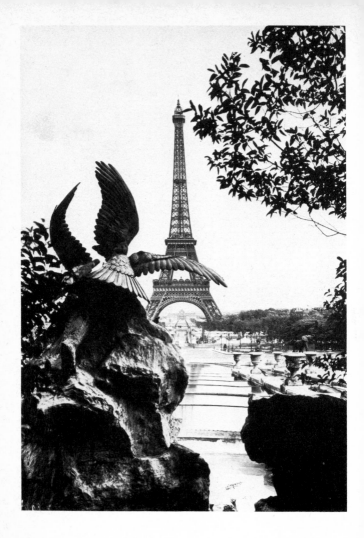

5 Gustave Eiffel, Eiffel Tower, Paris. 1884–1889

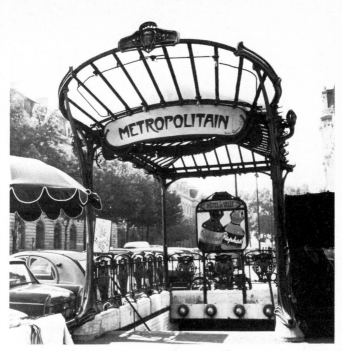

6 Hector Guimard, Métro station "Hôtel de Ville," Paris. 1899–1900

malleable mass needed by architects and artists in order to express the plantlike dynamism that is so characteristic of art nouveau. Equally important was the flexibility of the material from the point of view of stress mechanics. Narrow crossbeams of sectional iron were riveted together to form a system of apparently interchangeable right angles resembling those seen in children's building kits. Weightlessness triumphed.

A representative example of the use of iron and glass can be seen in the canopied roofs surmounting the métro entrances. The use of glass as a building material was, of course, long familiar in the construction of greenhouses and pavilions. This material had grown

increasingly popular in the latter decades of the nineteenth century. The individual panes were of a milky consistency that permitted only filtered light to penetrate into the interior, thus creating a clear boundary line between interior and exterior space. The function of the glass was therefore no different from that of the masonry in which it was framed (fig. 6). In contrast, Guimard's winglike canopies represent a union of glass and air. The individual panes are arranged to create a dynamic, floating effect while allowing the light to shine through in all its strength. Thus the very transparency of the glass becomes an essential stylistic element of the roof without reducing the stability of the structure in any way. The splendid appearance of this fan-shaped canopy is even more striking when illuminated at night. This architectonic deployment of glass was varied continually throughout the art nouveau period. Far from being limited to the construction of roofs and canopies, we find it in gallery windows, transparent façades, and above stairwells in arches like open umbrellas.

A fourth essential element, color, joins the union of glass, iron, and air. For example, the stemlike columns that provide a frame for the entrance of Guimard's métro station in Paris are not left in their crude elemental state but have been painted leek green. This intensifies the plantlike effect of the work and emphasizes the contrast between this structure and the everyday environment in which it exists. Art nouveau would be inconceivable without emphasis on color. In the architecture of the period we find at once brightly tiled façades, buildings painted a harsh bright white, and colorful ornamentation. Regardless of the discipline in which they worked, all the artists and architects of the movement believed that color had been "newly discovered." They preferred intermediate shades, gleaming with suppressed radiance, that appeared to possess a magical power. Decorative glass objects glow with a dull opalescent shimmer; jewelry is fashioned with semiprecious stones. It is not the brilliant ruby reds or the streaming sapphire blues that embody art nouveau's striving for "the grace and lyricism of the poet." Rather, the sickly pale color of the moonstone, the dull lilac of amethysts, and the mysterious glitter of agate reflect the desired mood. Nuance and unobtrusiveness—these are the hallmarks of an entire generation of artists, and it is here that art nouveau crosses

paths with contemporary symbolist movements. The symbolist notion of monochromatism is already reflected in the poetry of Verlaine, especially in his famous *Art Poetique:* "Car nous voulons la nuance encore, pas la couleur, rien que la nuance, Oh! la nuance, seule fiance, le rêve au rêve et la flute aur cor." Color is no longer used to define an object, to give it immediacy, naturalness, or reflected distance. Rather, color seems isolated from objects and becomes an independent medium for self-expression. In short, color has become a stylistic device.

The lettered panels on Guimard's métro entrance (fig. 6) are incorporated into the total composition in a striking manner. The flow of the individual letters repeats the gliding movement of the work as a whole; this flowing rhythm is the primary mood the artist sought to express through all of the various components of the design. The script is flat; the arcs and curves of the letters suggest continuity rather than spasmodic interruption. The plasticity of the railings is echoed by the sweeping curvature of the script, so that the whole structure suggests the amorphous expansion of a plantlike growth. This station sign represents a completely new form for which there were no models in the history of lettering. The sign was born spontaneously, as it were, to fill a momentary need. But Guimard's primary artistic concern was not to create an isolated decorative accessory. Rather, his purpose was to capture the homogeneity he perceived between the written word and the architectural design as a whole.

Art nouveau script cannot be adequately described simply by preparing a scholarly compendium of basic forms, for each artist sought to discover his own individual style. The interest these artists took in typography and script is revealed in the numerous newly founded journals through which each group sought to convey its ideas in graphic form. The tendency toward ornamentation was extended to letters in three-dimensional or cubic form. The doughlike quality found in many examples of art nouveau is reflected in these letters, as is the movement's symbol-laden language. The flow of the writing follows the leafy contours and tendrils of a plant; the capital letters are fashioned entirely as flowers. Initials often seem to bear only a faint resemblance to the actual forms of the alphabet, so that they appear to be independent

ornaments. No fixed rules for calligraphy existed at the turn of the century; however, script remained a significant component of the new principle of design.

The distortion of natural plant forms as a new stylistic device began with the "orchid lamps" of the Paris métro entrance. By transplanting these flowers into an entirely alien environment, Guimard succeeded in creating a pure symbol that had lost its connection with nature. The expressive possibilities afforded the artist by this process of alienation were manifold, ranging from the merely fantastic to the allegorical, symbolic, and, finally, surrealistic. The shafts of Guimard's lamps are so thin that the calyxes appear to float. The entire structure bends like a flower, exuding grace and the most refined cultivation.

The foundation upon which the floral variant of art nouveau developed was a new understanding of what was called *art naturiste*. There arose a new language of forms that took its themes and motifs, particularly flowers, from nature, although without stylization. The expressive power of this language was heightened by the artist's conscious choice of symbolic flowers. For example, iris and calla lilies, symbols of love, were chosen to represent freedom from care and worry. In contrast, the soft elegiac forms of the nightshade spoke of world-weariness, while orchids intimated the presence of all the mysterious and hidden secrets of nature. Art nouveau in France was particularly floral and luxuriant. Vegetable symbolism often infused an entire work of art. This was coupled with a predilection for asymmetrical forms and three-dimensional shapes. A yearning for the illusion of space is clearly evident in these works. Sculpted ornaments explode in profusion, devouring façades, entwining furniture, and enveloping other objects. "A chair is interpreted as if it were a plantlike growth made of the same substances that produce stems and buds" (Schmutzler). Nature is no longer the source of purely decorative images; emphasis is now placed upon its driving force.

Exotic plants are used consciously to create a particular mood that is at once contagious and seeks to envelop the spectator. Guimard's pictured lamps (fig. 2) exude sensuality through their erotic union of ornamentation and female symbolism. The flesh is perceived, consciously experienced, and dissected. At the turn of the century, we no longer see smooth, pleasing nudes free of an

aura of sensuality. Rather, artists active around this time portrayed erotic scenes that occasionally tended toward caricature because of their sketchlike quality. Since sexuality had previously been perceived as an anarchical and disturbing element that offended concepts of decency, the use of sexual symbols by artists of this period was meant as a protest. However, since these symbols were reduced to stylistic devices, the protest was merely an ostensible one.

The voluptuousness of the swelling form is held in check in our example by the tension of the contours. The globes hang suspended beneath the sensitive curvature of the linear columns supporting them. The leitmotif of art nouveau—the endlessly curved and flowing line—springs into life and triumphs.

The central impulse of art nouveau, which can be characterized as the complete liberation of surfaces and mass, must also be examined from a historical point of view. The side gates of Guimard's métro station are formed of loosely linked ornamental pieces undoubtedly modeled on the cartouche, a decorative element that was particularly popular during the baroque period. The cartouche consists of a shieldlike, flat surface together with a scrolled frame. Both art nouveau and baroque art are characterized by their expressive quality; hence there are a number of elements in Art Nouveau that are reminiscent of works of that earlier period. The elements common to both baroque and art nouveau include dynamic movement, constantly recurring waves and curves, the ornamental use of fish and insect motifs, the termination of a line in a scroll-shaped figure, and general emphasis on plasticity. Although it would be wrong to see art nouveau as an amalgam of earlier styles, it would be equally erroneous to overlook the presence of specific features also utilized by artists of the past. All these elements—the new and the old—are like small tiles that finally fit together to form the complete mosaic of the colorful artistic phenomenon called art nouveau.

Although interest in the critical study of art history began to deepen as early as the romantic movement, the effects of this intensified interest did not really become evident until the end of the nineteenth century. Art nouveau artists were nevertheless engaged in a genuine search for sources from which they could draw the richest inspiration. Their interest in and connection with the

past were both conscious and highly intellectual; their art should not be misunderstood as a sudden emotional outbreak of historicism.

A noticeable freedom in the designing of flat surfaces is an essential characteristic of Japanese art. This feature was enthusiastically adopted by art nouveau artists. The influence of the art of the Far East had been growing steadily since 1868 and is clearly evident in a number of examples of the new art. Graphics and painting as well as furniture and glass objects show the same tendency toward plantlike ornamentation. Similarly, lines of poetry were sometimes added to give extra emphasis to the content of a work. The expressive power of a functional object was also heightened by the artist's selection of particularly symbolic plants. As in Asia, this object was then regarded as a purely esthetic form. A further Far Eastern influence can be seen in the veneration of art nouveau artists for the line, which was considered "borrowed" from nature and used to divide surface space and break up mass. This principle of design is clearly evident in the lamps framing Guimard's métro entrance. Large plantlike structures rise up from the ground, decorating and filling space without creating a sculptural effect or the illusion of depth. Dynamism is achieved solely by the grandiose outlines of the sweeping curves of the stems. The refined intellectuality and subtle spiritual depth that was manifested in Japanese interiors, decoration, and applied art in general was largely responsible for shaping the attitudes of the young European artists to their own work.

It was not until 1854 that Japan first offered any considerable access to westerners. Until that time, it had drawn its creative inspiration solely from the Orient. Untouched by western influences, Japanese art was able to develop toward perfection in a constant interplay with religion and philosophy. Art was informed by a philosophy of nature in which the divine revealed itself in landscapes, animals, and plants. Works of art were meant to exist in a state of harmony with the needs and attitudes of the individual. Interior spaces expressed restraint and spiritual peace, as prescribed by the Buddhist religion. The foundation upon which the achievement of such complexity rested was a mastery of the craftman's tools that resulted in the production of objects of great purity and solidity. It thus came to pass that the crafts of ancient

Japan stimulated a new intellectual and artistic debate in nineteenth-century Europe. By 1859, many books about Japanese art and life had appeared. Artists everywhere welcomed these influences from the Far East and absorbed impulses from Japan with great enthusiasm.

The way the artist conceived of himself underwent a fundamental change. The idea of the "pure painter" or the "pure sculptor" no longer dominated artistic consciousness. New goals were to be realized by artists who could create a total work of art. Thus the architect created not only a building but actually designed everything else as well, down to the last detail. As a matter of principle, a "totally new creation" had to be expressed in every element of the work. The idea of the "shaper" in the most ambitious and demanding sense of the term was born, and the new feeling for style made itself felt in every possible avenue of expression. Hector Guimard embodied "the new artist" to the highest degree, for he was an architect, sculptor, craftsman, and cabinetmaker. Born in Paris in 1876, he became a student at the École des Arts Décoratifs and the École des Beaux Arts. Guimard's masterpieces include residential complexes, lamps, furniture, wallpaper, and presentation plates. The most remarkable element in his designs—and the basic philosophy of his entire work—is his use of free and asymmetrical form to infuse a work with dynamic vitality. The gliding sweep of a line is unbroken but allowed to turn in upon itself, forming concentric circles and condensing into a single point.

The great contribution of the art nouveau artist—as is also evident in various examples of Guimard's work—is a new feeling for the decoration of space, in particular the discovery of interior decoration. In the late 1890s, pieces of furniture were placed in rooms without any feeling for their inner relationship to each other. The profusion of pieces and the additional use of draperies, tapestries, and heavy tablecloths could not hide the fact that each table, chair, and sofa was imprisoned in its own isolation. Nothing united one piece with the others except a sense of narrow confinement. All feeling of the original function of a piece of furniture was destroyed in the midst of this false and superficial splendor. Of course, designers at work during the final years of the nineteenth century were aware of the demand for unified,

harmoniously proportioned rooms. However, this demand was met only in terms of stylistic purity in a historical sense: a room had to contain only one style—for instance, imitations of German baroque. The art nouveau artist understood harmony as something far more comprehensive. Working with almost missionary zeal, his goal in creating a unified, coherent interior extended to every object in a room as well as to the room itself as the framework of its furnishings. Every element was to become a link in a single unbroken chain. Thus the importance of every individual article diminished in favor of the effect of the room as a whole.

In addition to the need for liberating themselves from traditional artistic junk, the artists of this "decadent" period at the turn of the century experienced a yearning for an unfettered life far from the rush of civilization, a yearning to break away from society and its antiquated, stifling norms. These artists acted in an untamed and unruly manner, indulged in wild and extravagant parties; they appeared not to care in the least about public opinion. In art, these people preferred suggestive, sometimes obscene pictures. The model for this form of life was not the average man but the *homme ingénieux*. Nevertheless, these artists were doomed to failure. In the end they did not transcend the limits set by society; everything they did remained within the realm of the socially tolerable. Even their erotic and ecstatic pictures were tamed and tranquilized by esthetic form. Only one man found the path that led out of civilization and into the realm of harsh simplicity—Paul Gauguin. The art nouveau artists pretended to stride down this path too. However, they dared to take, at most, only a single little step.

The Problematic Aspects of Art Nouveau: Theory and Practice as Exemplified by Henry van de Velde

Hector Guimard's métro entrances, works of art in a public setting, were created to serve a public purpose. This commission fulfilled the sincere desire of many art nouveau artists to send their works out into the world at large. Henry van de Velde gave expression to this idea in 1890: "What is done only to pamper a single individual can almost be called useless; only what can be used by everyone will be valued by a future society." During the second half of the nineteenth century, William Morris wanted not only to reform art but also to change society itself. Admittedly, his views were expressed through the limited perspective of the production of arts and crafts. The idea of social reform was a major theme of art nouveau. However, when compared with our own values, this idea was also the movement's weakest aspect. Social reform on a broad cultural level never occurred. The first real unification of all of the arts did not occur until 1907, when a cooperative society for the production of art was founded. This occurred at a time when art nouveau was already being forgotten. If one recalls that the *Communist Manifesto* of Karl Marx and Friedrich Engels had appeared in 1848 and that Ferdinand Lassalle published *Capital and Labor* in 1864, one quickly realizes that the ideas of social reform associated with art nouveau at the turn of the century must be regarded as outdated and mere idealistic fantasy.

By the middle of the nineteenth century, William Morris had left the path of philosophical theory and turned decisively against the idea of an art for the elite. For Morris, art for everyone meant prosperity for everyone. At the same time, he demanded the elimination of all the luxurious accessories with which the rich surrounded themselves. However, it was difficult to reconcile these thoughts with Morris's simultaneous demand for a renewal and

reform of handicrafts and a rejection of all machinery. After all, it was only through mass-produced goods and high-quality industrial design that a "beautiful environment" could be made available to a large segment of the population. Moreover, only industrialization could finally bring prosperity to the masses. Morris failed to understand that only the actual redistribution of wealth would be able to create the conditions in which his artistic ideas could be realized. This was not likely to occur in England, a land of liberal ideas where social criticism could be freely expressed and new forms gradually developed. In contrast to England, people in Germany and France still believed in the idea of a rigid social structure in which the worker as well as the capitalist occupied a well-defined place. In this context, continental artists achieved new importance. Their terminology has a different sound for us today, living as we do in an era that has witnessed the Russian Revolution.

Around 1900, designs for private homes, especially the houses of wealthy patrons of the arts, provided architects and artists with a major creative outlet. This was the one area in which all the arts could be united. In Germany just after the turn of the century, a number of houses were built for such patrons and private collectors, who sought not only to satisfy their own desires but also to shape cultural and political life. For one thing, these people regarded themselves as an elite group whose task was to set standards of taste. Among the most prominent members of this wealthy German elite were Count Harry Kessler, Eberhard von Bodenhausen, Grand Duke Ludwig von Hessen, and Walter Rathenau.

> Under the influence of these active elitists, big business began to take an interest in artists whose work could be put to practical use. The anonymous corporate enterprise emerged as a 'patron' for the commissioning of art works. It is significant that it is impossible to discover who was responsible for one of the most spectacular of these contracts, the naming of Peter Behrens as Artistic Advisor and House Architect for the AEG [German General Electric Corporation]. (Wolfgang Pehnt)*

The greatest "manager of the muses" was Karl Ernst Osthaus, a banker's son and millionaire from Hagen who founded the Folkwang Museum. Osthaus engaged in propagandistic activities on all fronts—in his museum, in books published by his own

*See Bibliography for full source citations.

publishing house, in the architectural commissions he disbursed, through his numerous contacts in government and industry, and through the traveling exhibitions and lectures organized under the auspices of the German Museum for Trade and Commerce, which he also founded. We owe to the fortunate meeting of Karl Osthaus and Henry van de Velde some of the best and most comprehensive works produced during the entire art nouveau period.

In 1920, Osthaus wrote a book about van de Velde in which this patron of the arts evaluated his own "protegé." For Osthaus, van de Velde was a great "savior" and "prophet" who had absolutely nothing in common with the general currents of the art nouveau movement. Osthaus regarded van de Velde as a strict purist whose rather accidental encounters with the fashionable trends of the time had nothing to do with his universal plans for reform. He affirmed the idea of van de Velde as a great genius and reformer whose work was informed by only the purest motives. Osthaus's rhapsodic praise does not entirely miss the mark. Van de Velde saw himself as a savior and a revolutionary warrior whose work was in opposition to everything around him. He rejected everyone else, even Tiffany, Eckmann, and Horta, whose work he characterized as exhibitions of unbridled and undisciplined fantasy. He viewed Gallé's work as nothing more than "charming decadence." Van de Velde stigmatized art nouveau as a "bastardization of Pre-Raphaelite plant motifs and his own brand of linear ornamentation." Even the work of the Darmstadt colony was for him merely "decorative fantasy." Van de Velde's goals did, in fact, transcend all these things. First and foremost, he wanted to rid the world of its devastating greed for profit: "I have appeared like Providence, like a magician who causes new wellsprings to burst forth." Despite his exaggerated protestations, van de Velde was, in fact, the spearhead of the entire art nouveau movement. His words should not alienate our sympathies, for they arose in moments of great passion. His personal moderation and superior intellect allow us to overlook his pretentiousness. He announced his social ideas with enthusiasm and conviction, although his opponents accused him of contradicting his own desire for greater social equality by building luxurious villas for rich industrialists. Osthaus, of course, justified this activity by asserting that here too van de Velde was contributing to the "perfection of humanity." Osthaus's words reflect the typical

messianic spirit and "one-for-all" feeling that was characteristic of turn-of-the-century patrons. In truth, van de Velde was an extraordinarily gifted artist who was driven by an urge to create. This alone seems sufficient to legitimize his work.

New harmony, new esthetic clarity—these are the exalted goals van de Velde pursued throughout the enormously productive course of his life. It seems only fitting to let him speak for himself:

> I often ask myself what my objectives are. Introspective self-examination is the surest path I know by which to reach the goal toward which my work is headed, indeed, the goal towards which arts and crafts in general are striving. I believe my own work will be immune to danger only if it continues to conform to my artistic intentions. At the very least, my work will then benefit from the advantage of genuinely expressing the will of its creator. This is an advantage which I recognize in other works as well so long as they are the fruits of similar processes of self-reflection. Moreover, I assume that by becoming conscious of such inner harmony, other artists too will feel the same sense of security that comforts me when I reflect upon the harmony that exists between my goals and my work.
>
> It is necessary for each of us to be clear in our own minds about our artistic intentions and to structure our activities and measure their consequences accordingly. In this regard I am fortunate. My goals are easy to ascertain because they could not be simpler. Admittedly, the execution of my ideas forces me to come to grips with the thousands of details and practical considerations of material life. I could, of course, content myself with announcing a principle, describing the themes that would naturally arise from it, and explaining the esthetics on which the principle is based. In this way, I could easily design a building that would gain a measure of recognition and provide me with sufficient income on which to raise a family in comfort. However, an overpowering will forces me to transform into concrete reality every single principle that I have sent out into the world, in other words, to bear the entire weight of my ideas and not merely the lighter half of the burden.
>
> The "construction principle" in arts and crafts is not new; indeed, it has served as a foundation for art and architecture ever since classical antiquity. Unfortunately, it has been relegated to obscurity for some considerable time. However, its vital force has been eternally preserved in the enduring beauty and calm power of classical monuments, and I have no doubt that it will once again break through the ignorance and confusion of our times with serene clarity and emerge triumphant. I do not subscribe merely to traditional values,

however. Indeed, I regard the yearning for a new kind of harmony and new esthetic clarity as the cornerstone of all the artistic activities of our day. I share this yearning and seek to express it in arts and crafts through a new "construction principle," which, in my view, is the only valid principle we have. When I say that this principle is of fundamental importance, I mean that it should apply to everything—from plans for the design of a house to the design of the articles that fill it, even to clothing and jewelry. It is my goal to rid decorative art of anything that devalues it by making it senseless and lacking in purpose. In place of the old symbolic elements which can no longer have evocative power, I will substitute new and enduring elements of beauty. *(Was ich will,* 1901)

As we progress further in an analysis of van de Velde as an artistic personality, we begin to see that his central position in the art nouveau movement was not due solely to his artistic achievements but also to the contradictions that he resolved within himself. Van de Velde became a fixed star, as it were. If we begin to understand him, we begin to understand the problematic aspect of all art at the turn of the century. To the extent that the "riddle" of van de Velde's creative temperament can be solved, art nouveau can also be freed of much of its questionable content.

Van de Velde and his art have been the subject of numerous analyses. Criticism of his works has run the gamut from enthusiastic admiration to contemptuous rejection. To date it has been impossible to arrive at a clear and objective picture of this artist. In the hope that a dialogue would prove more fruitful than solitary research, I sought outside help in the form of an exchange of ideas with a person who knew van de Velde in the truest and broadest sense of the word: Klaus-Jürgen Sembach. He had not only grappled with van de Velde's work since earliest youth but also "experienced" him personally. Sembach first visited van de Velde in order to prepare for a seminar lecture. He traveled to Oberägerei near Zurich, where the artist was living in a simple, functional, flat-roofed wooden house designed by Alfred Roth, a colleague of Marcel Breuer.

The owner of the house had placed it at the artist's disposal. At the time, van de Velde's personal finances were not the best, since he had lost a substantial fortune through imprudent investment. Van de Velde's financial losses, however, in no way diminished his "worldly cheerfulness." Similarly, the relatively constricted

atmosphere of the rooms in which he was living did not take away from his image as a "grand seigneur." Posterity no doubt continued to think of van de Velde as a grand old man holding court in huge rooms furnished with select pieces of furniture; this was not the case. The visitor was led into small rooms furnished in a modern, unpretentious Swiss style that could not in any way be identified with the inhabitant of the house. Of his own works, all that remained were some pieces of silverware, albeit works of substantial significance. Otherwise, there were no traces of van de Velde's extraordinarily large and comprehensive output. Sembach did not visit an artist who lived in his own past; van de Velde was busy coping with everyday needs and his attention was focused primarily on current problems. From the artist's "guest book," a tablecloth embroidered with the names of his visitors, it was apparent that stimulating exchanges of ideas had taken place. The names of some of his visitors—for example, Richard Neutra and Alvaar Aalto—testify to the probable intensity of discussion. It is difficult to reconcile this life-style with van de Velde's much publicized vanity. (Sembach once told me that van de Velde had remarked in conversation: "Kandinsky could have become a good designer.") Hubris and nonchalant arrogance do not square with Sembach's evocation of van de Velde as a "wise old man on the mountain."

One can say that the metamorphosis that a person undergoes on a purely superficial level is deceptive. I remember photographs that show van de Velde as a relatively young man at the turn of the century. He was rather wiry and looked more Spanish than Flemish, although he later placed great value on his Flemish ancestry. I, however, met a grand old man with the imposing head of a cardinal. His head and in particular his nose seemed to have grown larger with age. The excessive nervousness that had evidently possessed him in earlier days had yielded to a serene attitude of interest in all that was going on around him. As for his reputed vanity and egocentricity, we did not talk only about him. I believe it is necessary to distinguish between vanity and an awareness of one's leading position. Every artist is vain and egocentric to some degree. In van de Velde's case, he had also constantly striven to support his artistic activity with theoretical formulations. The fact that his theory and practice did not always coincide was a matter of secondary importance. The important thing was the act of reflection, and this act was expressed in the many theses

and postulates with which this creator sought to control his extraordinarily lively artistic imagination. I believe that it was this conscious need for reflection that distinguished van de Velde from all the other artists working at the turn of the century. The others simply plunged headlong into the wealth of new possibilities offered and experimented without further consideration. (Klaus-Jüngen Sembach)

It is a fact that van de Velde did not want to be linked to the other artists of the period. Indeed, Riemerschmid was the only contemporary who gained his approval. Characteristically, in his writings van de Velde drew upon William Morris for support and not upon John Ruskin, who was greatly admired at the time. In van de Velde's view, Morris had been on the front lines of battle whereas Ruskin remained merely a talented esthete. Every artist of the art nouveau movement cut himself a slice of cake from the large (not always fully baked) mass of theories, opinions, and concepts that emerged at the turn of the century. Van de Velde was more precise and more honest. It is difficult to understand why, in spite of his superiority, van de Velde supposedly always felt "embarrassed" when people spoke about his art nouveau products. Sembach writes:

I observed none of this self-distancing from his earlier works. Moreover, I did not have the slightest cause to suspect such an attitude. I recall a photograph taken in 1952 when art nouveau was rediscovered at an exhibit arranged by the Zurich Museum for Arts and Crafts. It showed van de Velde seated in front of one of his masterpieces, the celebrated desk of 1899, telling about the artistic activities of the day. To me this picture contradicts the notion that van de Velde rejected art nouveau and sought to conceal his connections with the movement. The misunderstanding is probably due to the term "art nouveau" itself. Van de Velde had an almost allergic reaction to this term and asked me not to use it in connection with his work and himself. One must remember that for decades "art nouveau" had been a term of contempt and disrespect. As van de Velde was approaching the end of his life, art nouveau was only beginning to enjoy a cautious reassessment. Thus the artist's rejection of this shady expression was quite comprehensible. However, his dislike for the word itself has no bearing on and no relationship to his assessment of the value of the objects he created as a contribution to this movement. It would be a complete waste of time and entirely unnecessary to engage in a debate about the meaning of the term "art nouveau" today. The term has long

since become fully accepted and legitimized. However, it was problematic for an artist who had begun his career in the art nouveau period but who subsequently transcended the movement and kept pace with various other stylistic trends. One can say that the period around 1900 formed the theoretical foundation for van de Velde's work. It was not as influential with regard to form.

Van de Velde's powers of self-expression reached their apex in the art nouveau style. At the same time, his theoretical principles crossed the threshold of "modernity" and culminated in the founding of the Werkbund (a cooperative society in which the various branches of art were united). The art nouveau ornament, which van de Velde developed to perfection, reveals the extent of the artist's independence. It is here, however, that critics may well find substantiation for their reproach that van de Velde did not succeed in resolving the contradictions between his theory and practice, either in his art or his social criticism. Sembach noted:

> An artist who interprets his own work assumes a great risk. In limiting the possibilities for interpretation, he gives his critics specific weapons with which to launch an attack. The battle becomes more aggressive. Van de Velde's critics veritably pounced on the gap between his theory and practice. Their criticism is justified to the extent that this discrepancy was perceived and discussed. However, I believe it is false to measure van de Velde's oeuvre from the perspective of how close a particular work came to realizing a theoretical formulation. For me, it is much more important to recognize the problematic fact that a discrepancy between theory and practice had of necessity to exist in 1900. At this time, theory and practice had developed so independently and yet with such intensity that it is absurd to think that complete harmony could have existed between the two. Nevertheless, van de Velde strove to reconcile the various contradictions. In particular, he attempted to find a way to reconcile the vitality of an age truly bursting with artistic ideas with the strongly moralistic theses that had emerged in England during the nineteenth century. The chief error made during the period that antedated the First World War was that theoreticians thought they could save society "from above," as it were, by curing its ills through a highly individual art. What impresses me about van de Velde is that he was evidently always aware of the discrepancy between theory and practice. No artist of his time wrote as much as he did, and his endless reflections cannot be explained in any other way. It is this consciousness, I believe, that justified his position at the center of artistic activity around 1900. On the one hand, his

preeminence would be justified solely by the scope of his oeuvre. On the other, and what for me is more important, his central role was a function of the fact that his own life and work reflect the contradictions and problems inherent in an artistic existence at the beginning of the twentieth century. To date, these problems have not been resolved. I was enormously touched by the fact that during my lengthy conversations with van de Velde, the artist voluntarily admitted that he had never succeeded in rounding off his esthetic theories with a final conclusion. This admission deserves our sympathetic admiration, and does more than anything else to contradict the artist's alleged vanity.

Art nouveau artists felt the need to "guide the viewer" to ever higher heights in Goethe's sense. Indeed, this goal lay at the core of their creative activity. On the other hand, Morris had suggested realistic solutions to which these artists also felt bound. Can we see in this rather schizophrenic dichotomy a reason why the movement was so short-lived?

This dichotomy was a genuine tragedy for the artists who lived through it. If they wanted to realize their ideas, they had to devote themselves to enterprises that really contradicted their ideals. (It should be noted here that in spite of the superficial brilliance of the art nouveau movement, its artists had a difficult time establishing themselves and their styles, since there were relatively few public commissions.) The predominant activity in which creative ideas could be expressed was the building of villas for rich businessmen with artistic sympathies. What Morris had decades earlier called "the swinish luxury of the rich" remained now as before the nourishing basis for artistic creativity. However, one should also remember that after the fireworks of the years immediately preceding 1900, attempts were made to invest artistic capital in social enterprises. The establishment of the German Workshops and the Werkbund, the founding of workers' communes patterned after artists' colonies, van de Velde's involvement in the production of arts and crafts in Thuringia—these and similar phenomena shaped the decade before the First World War. This period was not as illustrious as the period before 1900 and for this reason it has often been ignored. In point of fact, it was more honest and also provided more stimulating impulses for future developments. (Sembach)

The original interest shown in the period around 1900, which could almost be described as exalted, gave way to a kind of skepticism. The almost narcotic effect produced by the costly

objects fashioned by art nouveau artists subsided. Critics began to apply more sober and rigorous criteria.

The difficulty we had in evaluating the art nouveau style was that the epoch was still too close at hand in a historical sense for critics to have achieved objective distance. Indeed, we still tend to connect art nouveau with the present and thus, retrospectively, apply criteria that are valid only for the art of today. We are the ones who perceive art nouveau, whose decline we can now just begin to follow, as an exalted, contradictory, and morbidly fascinating movement. We experience the style in the same way that we would experience a visit to a great-grandmother's house. If, on the other hand, we try to imagine the art nouveau style from the perspective of the artistic and social problems that existed in the nineteenth century, we see that the movement represented a real breakthrough to clarity, transparency, and decorative discipline. It should be recalled that art nouveau first rescued color for architecture as well as for every other aspect of human life. The decorative element in particular must be stressed, since many of the movement's most violent critics have approached the art nouveau style as if this aspect did not even exist. One reason for this fundamentally erroneous approach is that undue emphasis has been given to the fact that in his later works van de Velde gradually came to reject classicism and embraced a form of architecture that was purely functional and devoid of ornamentation. In this regard, van de Velde differed from almost all his contemporaries. Moreover, by this time he no longer held the leading position that he enjoyed at the turn of the century, although admittedly he was able to establish contact with and attract a younger generation. (Sembach)

The fact that van de Velde ceased to function as the leader of art nouveau was not due to a change in the quality of his work. Rather, his creative activity proceeded in distinct phases, each one yielding to the next in a constant process of growth and regeneration.

People often speak of "international art nouveau," since the movement encompassed all of Europe and ultimately spread to America. However, the historical period immediately preceding the First World War was distinctly and inevitably nationalistic. Indeed, the mutual openness and interaction among the best artists of the movement became problematic in light of political currents. Sembach observes:

Another reason for van de Velde's special position at the turn of the century was his cosmopolitanism. No other artist of the period

succeeded as he did in transcending geographical boundaries. Constrained by the limited opportunities afforded him in Belgium, he turned to Germany with its richer possibilities. In 1897, Bing exhibited van de Velde's work in Paris; this Parisian sojourn remained merely an interlude, however. And yet, all his life van de Velde had hoped for a career in France. This great desire was never satisfied, and his subsequent attempts to establish himself failed. His works did not find the hoped for response. Van de Velde's predilection for the French language as well as his tendency toward elegance, sophisticated cosmopolitanism, and *causerie* should have destined him for a leading position in Paris. However, he was probably too German for the French mentality. This situation was indeed remarkable: non-German people came to regard a non-German artist as one of the most typical representatives of German artistic trends. Just how unhappy van de Velde was about his rejection in Paris was evident in our conversations. Among other concerns, he was greatly troubled by not having found a French publisher for his memoirs. The bilingual quality of this work of van de Velde's mature years was an inner necessity and one that should certainly be respected by a German publisher.

Van de Velde was a central figure in the art nouveau movement. Yet his artistic criteria around 1900, which were one with the general artistic goals of his times, were anachronistic. Van de Velde never created designs for mass production. His artistic requirements were too high for this, and he was not prepared to sacrifice his ideals for the purposes of duplication. In his diary, André Gide describes a luncheon meeting with van de Velde: the artist refused to eat the fruit that was offered him, observing that these beautiful objects were meant only to be looked at. Exaggerated estheticism and the seeds of modernity—both ends of the spectrum were contained in art nouveau.

The Schools, Communal Workshops, and Centers of Art Nouveau

The establishment of communal workshops for the creation of art nouveau works was an everyday occurrence around 1900. The new sensibility had to be communicated to others and the creation of "total works of art" needed the energies of a whole community of people in order to be realized. We shall now describe in detail the various groups that were most significant in the development of art nouveau. Particular attention will be given to the most representative artists and workshops of the movement.

Brussels, one of the centers of the movement, was quite early on a meeting place for avant-garde artists. Their spokesman was Octave Maus, who had founded the periodical *L'art moderne* in 1881. This publication was quickly adopted by two groups of artists who called themselves the Cercle des Vingt (1884–1893) and La Libre Esthétique (1894–1914). Brussels was a more artistically liberated city than Paris. As early as the 1880s, the works of Auguste Rodin, James McNeil Whistler, Odilon Redon, Georges Seurat, and Paul Gauguin were publicly exhibited there. Van de Velde became a member of the Vingt in 1889; in 1890 he was joined by Vincent van Gogh, Jan Toorop, Fernand Khnopff, and Redon. By 1894, the Libre Esthétique was exhibiting English silver by Charles Robert Ashbee, fabrics and wallpaper by Morris, and drawings by Aubrey Beardsley. Influences from the symbolist movement in France were also beginning to make themselves felt. Not all well-known Belgian artists became members of a group, however. Victor Horta and Georges Minne, for instance, never joined an association. They nevertheless maintained contact with each other and participated in lively exchanges of ideas. Their influence spread to Holland and was particularly manifest in the works of Toorop and Jan Thorn-Prikker.

In **France,** the Nancy school was particularly important in the development of art nouveau. Just as significant, however, were the

activities of one man, Samuel Bing. Born in Hamburg, Germany, Bing had been publishing his *Treasury of Japanese Forms* since 1888 in German, French, and English. This publication was a sort of guidebook and reference work designed to stimulate the creation of new forms. Bing performed countless services for art nouveau. He traveled throughout Europe and the United States in a constant search for new art works. In 1896 he exhibited the works of van de Velde in Paris; a year later he exhibited them in Dresden. Van de Velde was greeted with enormous enthusiasm in Germany, which helped him to break into the art world. In Paris, however, the reception of van de Velde's work was reserved, and he achieved little recognition. Henri de Toulouse-Lautrec, however, had a house built in the so-called "yachting style," a term invented by the Goncourt brothers to describe what they thought was the new "German style." Bing not only exhibited the works of all the well-known artists of the period—such as Guimard, Gaillard, Gallé, and Majorelle—but also commissioned tapestries, furniture, and even whole interiors. He promoted painters like Edvard Munch and introduced the works of Louis Comfort Tiffany to the European continent.

In 1891, the Parisian periodical *Revue Blanche* was founded, uniting the work of the most important artists with that of the most advanced writers. This publication became the mouthpiece of the so-called nabis. Pierre Bonnard, Edouard Vuillard, Felix Vallotton, and Toulouse-Lautrec designed the title pages, advertisements, and graphics that were included in the periodical. In the editorial offices, they met and exchanged ideas with van de Velde and Munch.

England was particularly rich in publications. The periodical *Hobby Horse* was published by the Century Guild. In 1889 *The Dial* appeared. This magazine, like *Hobby Horse*, cannot really be regarded as an art nouveau publication; however, it did formulate several ideas that were of fundamental importance to art nouveau. Through *The Studio*, founded in London in 1893, the ideas of William Morris influenced all of Europe. To these publications we must also add *The Yellow Book*, a yearbook that first appeared in London in 1894.

In **Germany,** *Pan* was the first periodical that actively supported the art nouveau style and contributed in a substantial way to the

spreading of the programmatic artistic ideas of the movement. By leafing through this periodical, one can see the continuous development of art nouveau lettering during the particularly productive years between 1895 and 1900, from its cautious beginnings to the most mature works of Peter Behrens. This quarterly publication was extremely elaborate and quite splendid in its layout and organization. Its special editions contained original etchings and lithographs by almost all the well-known art nouveau artists of the time. The spiritual father of this journal was the art critic Julius Meier-Graefe, whose cosmopolitan candor can be felt everywhere in its pages. *Pan* was published by the Society of Pan and printed by Fontane & Co. in Berlin. It was edited by Wilhelm von Bode, Eberhard Baron von Bodenhausen, Caesar Flaischlen, Richard Gaul, Otto Erich Hartleben, Count Harry Kessler, Karl Koepping, Alfred Lichtwark, and Waldemar von Seidlitz, all of whom played a decisive role in shaping the direction of art nouveau from their vantage point in Berlin.

Czar Alexander of Russia subscribed to this lavish periodical, the copperplates of which were printed on fine Japanese paper. The first issue of the second year of its publication was introduced with the following preface:

> *Pan* is a German periodical for art and literature; it does not exist to serve only one particular direction or movement but will attempt to present a total picture of all the creative powers now active in the world of art. In its artistic format, *Pan* will continue to strive for the highest standards now attainable in Germany.

An excerpt from the table of contents indicates this periodical's many-faceted character: poetry by Theodore Fontane, Christian Morgenstern, and Paul Verlaine; essays by Alfred Lichtwark; illustrations by Max Liebermann, Walter Leistikow, Ludwig von Hofmann, Adolph von Menzel, and Thomas Heine; and, as a special supplement, an original lithograph by Edouard Vuillard.

The periodical *Jugend,* edited by Paul Hirth in Leipzig and Munich, was more popular than *Pan,* but it was also conceived on a less elitist level. Advanced spirits concerned with the art of book design discovered a further field for their activities here. *Simplicissimus,* which was founded one month later, achieved the same importance as *Jugend.* Bruno Paul, Thomas Theodore Heine, and Olaf Gulbransson were the most important graphic artists

represented in this periodical. In 1897, countless art periodicals began to appear in Germany. Among them were *Kunst und Handwerk* in Munich and *Die Dekorative Kunst* in Darmstadt. Both these journals were concerned almost exclusively with problems of interior decoration, which was one of the major preoccupations of art nouveau artists. This led to the founding of two associations, the Vereinigte Werkstätten für Kunst und Handwerk (United Workshops for Arts and Crafts) in Munich and the Dresdner Werkstätte für Handwerkskunst (The Dresden Studio for Handicrafts). Two periodicals oriented toward art and decoration appeared in Paris: *Art et Décoration* in 1897 and *L'Art décoratif* in 1899.

In **Holland** an organization called Architectura et Amicitia was founded in 1893 and soon published a periodical entitled *Nieuwe Kunst.* With the collective efforts of almost all the artists working in the new style, a business venture was begun in Amsterdam in 1900 called t'Binnenhuis Inrichting tot Meubilering en Versiering der Woning (The Inner House Establishment for Furnishing and Decorating the Home). The periodical *Kunst und Industrie,* which was comparable to *The Studio* in London, had already appeared in 1877. *Van un en straks,* which bore many similarities to *Pan,* appeared in 1892.

In **Austria,** the periodical *Ver sacrum* served as the mouthpiece of a group of young artists who had banded together to form an association called the Vienna Secession. Gustav Klimt, Koloman Moser, Josef Hofmann, and Rudolf von Larisch, the great Viennese book illustrator, gave this publication its unique quality.

In **America,** William H. Bradley published the *Chap Book.* During the two-year period of its existence, illustrations for it were supplied by Toulouse-Lautrec as well as countless other European artists.

No fewer than a hundred periodicals were founded in Europe around 1900, the period of the art nouveau movement's artistic awakening.

Nancy

Along with Paris, the provincial city of Nancy also became a center of art nouveau. In the works of the Nancy school we find the best

examples of the new style in its floral form. The program of this group makes it clear that a number of like-minded artists had joined forces primarily to liberate themselves from old-fashioned artistic styles and the established rules of the academies. The expressive style of this school was based upon a particular relationship with nature, from which forms and motifs were borrowed and employed without any stylization. Plantlike decorations spread out over the entire surface of a typical work (fig. 7), which appears quite literally to be engulfed by the vegetable kingdom. Other important elements, such as a preference for asymmetrical forms as well as a *vue d'ensemble,* recall the art of the European rococo period. Symbolic tendencies were expressed by means of inscriptions chosen by the artists of the Nancy school. This explains the terms *meuble parlant* or *verre parlant.* The inscription on a desk by Gallé, inlaid in various woods, reads *travail et joie* and can be regarded as an expression of the programmatic attitude of the entire Nancy group toward "natural nature": the object should not only express its function through its form but should also evoke a mood in the viewer. Decoration, then, is supposed to mediate the artist's intentions as well as a particular mood. The goal was to have a symbolic dimension; on the other hand, artists were encouraged to engage in esthetic experiments that would result in overcoming pure functionality. The Nancy school came close to adopting the view that the significance of naturalistic decoration lies in its symbolic content. As Emile Gallé wrote: "Separating symbol from decoration is like removing the moon from the sky." (Emile Gallé, "Le Décor Symbolique," in *Ecrits pour l'art,* 1908).

The World's Fair of 1900 established the success of the "masters" of the Nancy school. Self-confident in their work, the artists of that city turned their attention to establishing common studios. Indeed, communal work became their highest goal. In addition, they organized annual exhibitions in order to bring their works and ideas to the attention of a broad spectrum of the public. They also sought

7 GLASS *(from top left to bottom right):*
 Louis Comfort Tiffany, Favrile glass, ca. 1897; Ernest Leveillé, Vase, ca. 1897; ▷
 Koloman Moser, Decorative glass, ca. 1903; Emile Gallé, Bowl, ca. 1885; Louis
 Comfort Tiffany, Favrile glass, ca. 1900; Louis Comfort Tiffany, Favrile glass, ca.
 1896; Antonin Daum, Layered glass, ca. 1895; Louis Comfort Tiffany, Favrile
 glass, ca. 1900; Josef Pallme-König, Glass vase, ca. 1900

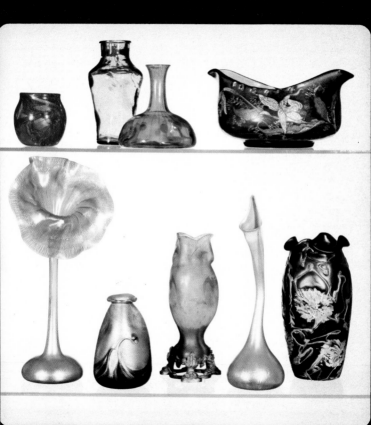

to remedy deficiencies they perceived to exist in the training of the next generation of craftsmen. They supported a reform in the teaching of drawing and the establishment of an apprenticeship program. It can be assumed that in undertaking these measures, they wanted to assure the continued existence of their artistic vision. To this end, they made efforts to adapt the old skilled crafts to the mechanical requirements of modern industry. Victor Prouvé in particular dedicated himself to this important scheme. He directed the attention of factory owners to the skilled crafts and also sent young artists trained by the masters of the Nancy school into factories in order to give an artistic impulse to production. Antonin Daum summarized this goal in three points. First, mass-produced decoration should be based on an artistic model; the artist must never lose sight of an object as a work of art. The masters who were responsible for achieving an interplay between art and industry had to be responsible for the integrity of the finished product. Second, defects in the training of the new generation had to be remedied and young artists were to be helped to pass beyond mediocrity. A musée d'art appliqué should provide a forum for the exhibition of the works of the new generation. This would provide them with incentive for improvement. Third, industry should use its vast financial resources to promote the creation of decorative works expressive of the ideas of the Nancy school.

Emile Gallé (1864–1904) was the driving force behind all these ideas and the founder of the Nancy school. Under his direction, glass art reached its highest peak of perfection. Since Gallé's father owned a small glass and ceramic factory, he became familiar at an early age with the materials he was later to use in his art. He worked in Meissen and also studied philosophy and botany. During a stay in London, Gallé came into contact with the art of the Far East and opened himself fully to its influence. In addition to creating highly perfected glass works, Gallé also dedicated himself to the art of cabinetmaking. A number of artists united under his leadership. Under Gallé's influence, Antonin Daum (1864–1930) completely converted his glass factory in 1893 to the exclusive production of glass art works. Eugene Vallin (born 1856) was a designer and craftsman of fine furniture. He was distinguished from Louis Majorelle (born 1856) in that he devoted himself almost entirely to this one craft, whereas Majorelle ultimately engaged in all the

branches of applied art. Victor Prouvé (born 1818)—a painter, sculptor, bookbinder, and goldsmith—was an enormously vital artist who constantly provided the school with new inspirations. From the very beginning of his career Prouvé collaborated with Gallé and, after the latter's death, operated the Gallé glassworks for another twelve years. It was under Prouvé's direction that the École des Beaux Arts de Nancy achieved its worldwide reputation. To this list of the artists of the school of Nancy should be added the names of the architects Charles and Emile André, the interior decorator Camille Martin, and the bookbinder René Wiener. The art historian Roger Marx (born 1859) also belonged to this circle. Marx lived in Nancy until 1882, later moving to Paris, where he wrote impassioned articles in praise of the Nancy school.

Art nouveau as it developed in Nancy had a unique character. Of foremost importance was the artist's special relationship to nature and the characterization of his work as *art naturiste*. Similarly decisive were the influence of Japanese art and the rococo tradition. It is important to note that Nancy houses one of the best examples of rococo art in all Europe, the celebrated gates of the Fountains of Lamour. Consequently, local artists felt bound to continue the proud tradition of their city. In the words of Gallé, *"Nos humanités toutes fraîches savouraient le régal d'une science aimable, d'une atticisme jolie comme les gui-pures dorées de Jean Lamour."* ("Our classically trained spirit takes delight in the charming, finely wrought golden gates of Jean Lamour.")

The influence of Japanese art came to Nancy by a direct route. In 1885, a Japanese named Takasima began to study botany in Nancy's École des Forestiers. He soon formed a close friendship with Vallin and Gallé, and there is no doubt that the presence of Takasima deepened their interest in Japanese art. After the exhibition of 1889, Emile de Vogue, writing about Gallé, observed: *"Benissons le caprice du sort, qui a fait naître un Japonais à Nancy."* ("Let us be thankful for the fortunate accident that a Japanese was born in Nancy.")

After the floral form of art nouveau exemplified by the Nancy school had achieved recognition, countless artists from Lorraine also attempted to create works in this style. However, many of these were mediocre, with the result that in the following years art nouveau lost much of its high reputation.

Paris

In contrast to most of the other major European cities, Paris did not give rise to an independent group of artists or a commonly created and accepted program of artistic principles. What united artists here was Paris itself—both the city and its glittering cultural life at the turn of the century. In this sensual city, the vegetable-ornamental style of art nouveau reached its apex. In the examples of art nouveau created in Paris, theory and practice were never in conflict. Humanity's connection with nature was stressed everywhere. Parisian artists did not possess a naive "wanderer's" mentality; they did not rush out on hikes and sing hymns of praise to trees and flowers. Rather, they possessed an elitist consciousness of belonging to nature and participating in a constant process of death and regeneration. Their literary ambitions were not concealed. A line of poetry by Baudelaire placed unobtrusively upon a piece of furniture betrayed the close relationship between art nouveau artists and the literary symbolists. Indeed, a line of poetry from Charles Baudelaire's *L'invitation au voyage* can equally well serve as a motto for the whole variant of art nouveau created in Paris: *"La tout n'est qu'ordre et beauté, luxe, calme et volupté."* ("Reigning there are only order and beauty, luxury, calm, and passion.")

The façade of an apartment house by Jules Lavirotte (fig. 8) reveals a concentration of all the decorative elements of art nouveau. Like a spider's web, a net of thistlelike plant forms covers the masonry. If one were to remove it, the house would remain like a box and the ornamentation could then be placed on any undecorated surface. Yet the ornamentation possesses a mysterious power that holds the building together and awakens in the viewer a "passion to look." It calls up the image of an overgrown lake. The art nouveau love for water, which reflects a mood whether sparkling in the daytime or shimmering darkly at night, finds expression here too, if only by association and in alienated form. The almost "movable" decoration of the façade could just as well be used in designing a piece of furniture. The plastic, circular lines would be equally effective if allowed to flow over the surface of a chair as they are on the façade of a building. The structural pattern of the building is subordinated to an abundance of movement and ornamentation. It is significant that art nouveau craftsmen such as Georges Hoentschel, Louis Majorelle, and Emile

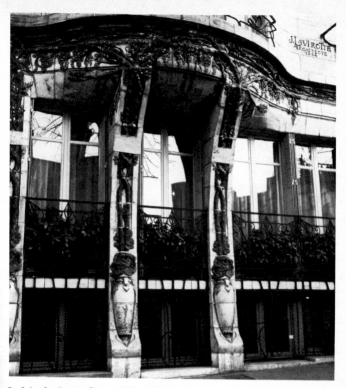

8 Jules Lavirotte, Ceramic Hotel, Paris. 1904

Gallé first made plaster models for their furniture; they conceived of furniture not as architectural form but as sculpture. A piece of furniture had to be valuable and stately; less value was placed on function. The French artists did not invent any new ideas in interior ~oration—space was merely filled up with luxurious individual ~es of furniture. Traditional design was not revised. No one ~d "why"; only the "how" underwent a change. An elegant way ~ife required elegant furniture: delicate sofas, upholstered ~hairs, dignified sideboards. This formulation may sound ~rative. However, one must remember that French art ~veau—in its intentions and realizations—should not be ~pared with and judged by the idealistic principles and

9 Georges Hoentschel, Armchair. Ca. 1900

10 Eugène Gaillard, Sofa. Ca. 1900

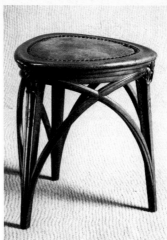

11 Alphonse Mucha, Stool. Ca. 1900

exploratory motives that characterize English and German art
nouveau. Its charm lies precisely in its luxuriant beauty. Georges
Hoentschel's armchair (fig. 9) clearly shows this. It is a first-rate
example of "stately sculpted furniture." Yet its construction
remains uncertain: it is difficult to distinguish the basic framework
from the added decoration.

Eugène Gaillard's furniture is much lighter. In his sofa of 1901
(fig. 10), we see the subtle plasticity typical of Gaillard's delicate,
slender-limbed pieces. The sofa seems designed to be looked at
rather than used. One does not sit down and rest here; one gazes at
the esthetic beauty of the work, whose attractiveness lies essentially
in its decorative quality. In 1902, Alphonse Mucha designed a
simple stool (fig. 11) in which the structural arrangement of simple
decorated lines creates a feeling both of tension and economy. This
piece displays a close affinity with Guimard's métro "tulips" (fig. 2)
asked the sweeping dynamism of its basic contours takes
of j over its decorative elements, which are restricted to
armc Alexandre Charpentier's music stand (fig. 12) is a high
pejc ench art nouveau design. Its scalloped base seems to
nou of the earth. The grooved wooden columns with their
com ed edges flow downward into the base in wavelike curves,

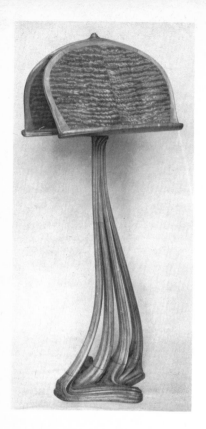

12 Alexandre Charpentier,
Music stand. Ca. 1900

while the stalks are gathered together at the top just before joining
the music stand proper, which calmly absorbs the impulses rising up
from the floor. This note stand is truly "musical;" free of excessive
decoration, it is a harmonious, rhythmical composition in wood
that points to and beyond Majorelle's piano (fig. 13). The massive
housing of this musical instrument contains an inlaid picture of a
mother rocking her child to sleep. This picture bears no direct
relationship to the piece of furniture in which it appears; hence the
sentimental and naturalistic representation can be regarded as pure
ornamentation.

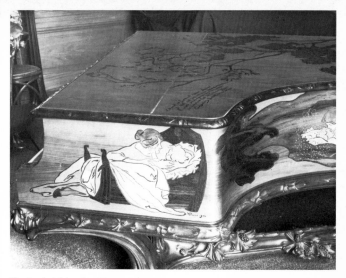

13 Louis Majorelle, Piano. Ca. 1900

Majorelle remained remarkably conservative in his furniture designs. This contrasts sharply with his simple ceramics as well as with the banister he created around 1901 (fig. 14). The latter example combines a sense of vigorous movement with the naturalism and delicacy of plants. Both the vertical rods and the connecting spaces are adorned and filled with gracefully curved and intertwined flowery forms perched upon long linear stalks and crowned by leaves resembling the petals of calla lilies. Schmutzler speaks of "biological romanticism" and concludes:

> The sweeping curves, the pulsations, the bursting into flowers and buds are clearly conceived as bimorphous organic animations. In many cases, these natural forms are reminiscent of anatomical models. Still more often, one is forced to think of that strange intermediary world of plantlike lower animals that inhabit the floor of the sea and whose mysterious, even repellent grace and elegance and half-sucking, half-floating movements have always fascinated artists.

Schmutzler's observations seem to be confirmed by Gallé's glass objects and furniture. The legs of the table he created around 1900

51

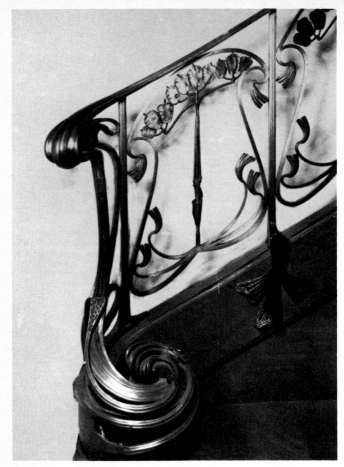

14 Louis Majorelle, Staircase. Ca. 1901

(fig. 15) are oversized dragonflies whose heads support the tabletop like caryatids of the ancient world. The original, naturally curved shape of these insects' bodies has been exaggerated almost to the point of being grotesque and ugly. However, esthetic harmony is restored by the sophisticated treatment of the smooth horizontal surface. The forms of lower animals were generally selected by art

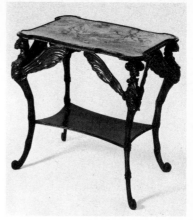

15 Emile Gallé,
 Dragonfly table. Ca. 1900

nouveau artists for two reasons. In the first place, they were closer
to the origin of all life; second, the pulsating elasticity of their
delicate limbs made them living embodiments of the art nouveau
ideal of the curved line. The outline of Gallé's tabletop is
conventional and somewhat stiff; indeed, it serves merely as a
framework for the complex interior inlay fashioned out of
multicolored pieces of wood. Precious inlay was characteristic of
Gallé's furniture in particular and of the Nancy school in general.
Against a grainy, heavily veined background, carnations have been
"randomly" scattered and the fibrous petals of these flowers serve
to animate the whole composition (fig. 16). It is interesting to note
that the carnation is included in the bouquet of the *Fleurs du mal*.

In the context of flower mysticism, the carnation is a symbol of
bad luck and evil and is therefore a useful design for the evocation
of a particular mood. A further example of the fusion of a symbolic
language of form and applied art is Gallé's buffet (fig. 17), a totally
bourgeois piece of furniture that is rendered strange and exotic by
means of its allegorical representations. For Gallé, the arrange-
ment of elemental natural forms was as important as linear
dynamics and the choice of delicate colors. His vases, which are full
of symbolic expressiveness, can be described as plantlike growths
that have been frozen in motion. This quality is characteristic of all
art nouveau glass objects, for example, those of Antonin Daum

16 Emile Gallé, Tabletop (detail; see fig. 15). Ca. 1900

(fig. 18), Albert Dammouse, and François Décorchement (figs. 18 and 26). Eugène Rousseau's amorphous vases, which totally lack color and ornamentation (fig. 19), can be described as vessels frozen in a crystal flux. However, the colorless mass is enlivened by silver or gold tinsel flecks which reflect the light with a cold, metallic luminosity.

> This light, which shines down upon the reflecting substance from outside and yet seems to come from the interior of the vessel, and is, in fact, transformed by the object, is highly symbolic and suggestive of irrationality. This is why the symbolists found their eternal homeland in Byzantium, which glitters in the reflected brilliance of its majestic yet austere gold mosaics, as well as in the Orient, where light refracted from the infinite facets of splendid jewels sparkles in endless color only to disappear in the gloomy haze of opium clouds. (Hofstätter, *Symbolismus . . .*)

The jeweler René Lalique was one of the most celebrated artists of the art nouveau movement. In his creations, symbolic and naturalistic elements flow into and join forces with lyrical components to produce an exotic effect. Lalique had been a student

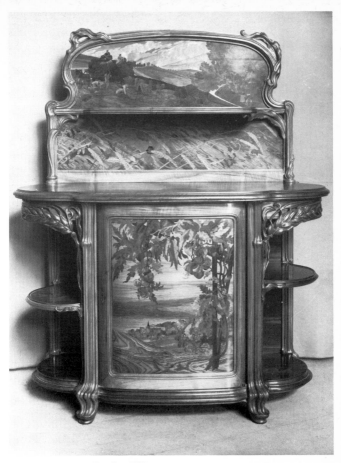

17 Emile Gallé, Buffet. Ca. 1900

at the École des Beaux Arts. By the time he was twenty-five, in
1885, he had set up a jewelry workshop in Paris. His first public
appearance in the Salon de Mars in 1895 created a sensation. In
1900 he was the undisputed victor at the World's Fair. Lalique's
work also represented a reaction, this time against the highly
developed but stagnating art of jewelry design that prevailed in

imperial Europe. The jewelry of the period was extraordinarily valuable. Diamonds continued to be the favorite stone and were often artfully combined with emeralds and sapphires. Indeed, the value of a piece of jewelry was measured only by the quality of its stones and the way they were cut. For Lalique, design became much more important than the costliness of a particular stone. He regarded a piece of jewelry as if it were a painting; thus, it had both an illustrative and a narrative function. His jewelry has a "fairy tale" quality because it combines "poetic content" with rare and exotic esthetic beauty.

In Lalique's jewelry, delicate leaflike structures send forth shoots and tendrils that appear to come together of their own accord to form a piece of jewelry. In the example reproduced here, the graceful, curved body of a sea nymph, whose hands provide the setting for a decorative stone, forms a diadem (fig. 20). Lalique shared with other art nouveau artists a preference for unconventional motifs drawn from symbolic naturalism. He, too, regarded plants as living beings. Like the others, he chose flowers, primarily withered ones, as decorative elements. Finally, Lalique also frequently used mythical figures such as mermaids, seahorses, and young maidens rising from the calyxes of flowers. Flowing hair, which was regarded as a fascinating medium for expressing movement in a manner that was at once provocative and full of symbolic charm, is delicately stylized in Lalique's works. Lilies, orchids, water lilies, and butterflies are captured and preserved in transparent objects of extraordinary sumptuousness. Just as a highly developed technique in the art of glassmaking was a prerequisite for the glass objects of art nouveau, so, too, Lalique's artistic achievements as a goldsmith were based upon earlier experiments with semiprecious stones, enamel, and cloisonné.

18 PORCELAIN AND GLASS *(from top left to bottom right):* ▷
 Emile Gallé, Layered glass, ca. 1895; Juriaan Kok, Cocoa cup and saucer, 1901;
 Juriaan Kok, Cup and saucer, 1901; Charles Robert Ashbee, Silver goblet, 1902
 (see fig. 52); Juriaan Kok, Vase, 1900. Camille Naudot & Cie., Drinking glass,
 1894; Albert Dammouse, Small bowl, ca. 1900; Fernand Thesmar, Small bowl,
 1903; François Décorchemont, Small bowl, ca 1905; Albert Dammouse, Footed
 bowl, ca. 1900; Albert Dammouse, Bowl, ca. 1900; Antonin Daum, Ornamental
 glass, ca. 1905; Juriaan Kok, Vase, 1913; Juriaan Kok, Vase, 1909; Juriaan Kok,
 Vase, 1900; François Décorchemont, Drinking goblet, ca. 1905

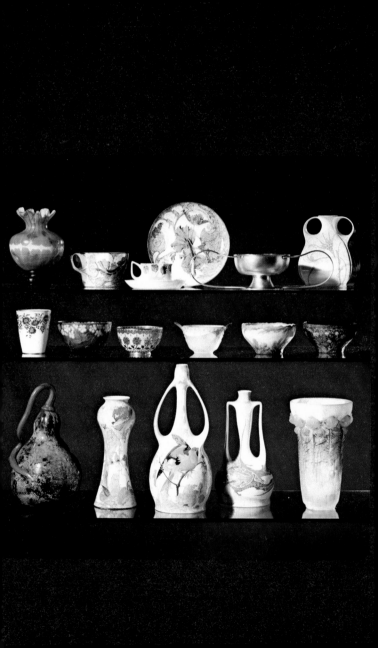

19 Eugène Rousseau,
Vase. Ca. 1900

Among Lalique's contributions was the development of new subdued tones whose beauty was enhanced by light, especially natural light. Unlike diamonds, which sparkle all the more brilliantly in artificial light, Lalique's creations reveal the full beauty of their coloring in the light of day. As a complement to his subtle coloring, Lalique also successfully employed a whole range of new materials: semiprecious stones, amber, mother-of-pearl, tortoise-shell, horn, pearls, and base metals. Lalique's jewelry creations were hybrids, a combination of sculpture, painting, and arts and crafts, and it is this union which is ultimately responsible for the unique and enchanting effect of his works. Lalique's art was often imitated, not so much by jewelers but by architects, painters, and craftsmen. The most important of these artists were Alphonse Maria Mucha, Henry Vever, and Eugène Grasset.

Mucha, who was born in Czechoslovakia, was a very versatile artist. Between 1898 and 1905 he designed works for the Parisian jeweler Georges Fouquet. One of these pieces, a brooch (fig. 21), is a portrait of Sarah Bernhardt as Melisande. Mucha's favorite

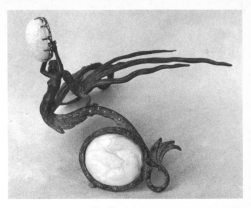

20 René Lalique, Diadem. Ca. 1900

theme was woman, an archetype represented in all his works as a mysterious, dreamlike being. A water nymph adorns the comb designed by Grasset (fig. 22), who embodied the attitude of yearning typical of all art nouveau artists in the dreamlike, delicate female figures that appear in all his pictures, sculptures, and graphics (fig. 23). Lalique's most skillful imitator and a virtuoso in his own right was the Parisian jeweler Vever. However, traditional elements such as diamonds and other precious stones again became important in his work (fig. 24). In Vever's pieces, the artist triumphs over the lyric poet.

Hand-printed wallpapers were another genre in which the delicate floral patterns of art nouveau found expression. As was the case with the jewelry of the period, so, too, the wallpaper designs lacked all trace of heaviness and mass. Nearly all the leading artists of the period engaged in wallpaper design, since this was an ideal medium in which to experiment with color and background. "The wall became a backdrop for pictures, furniture, and people; one 'saw' things for the first time against the background of a wall . . . the wall itself aroused feelings of sympathetic response in the viewer." (Hans H. Hofstätter, in Bauch/Selig [ed.], *Jugendstil . . .)

21 Alphonse Mucha, Brooch. Ca. 1895 ▷
22 Eugène Grasset, Comb. Ca. 1900 ▷ ▷

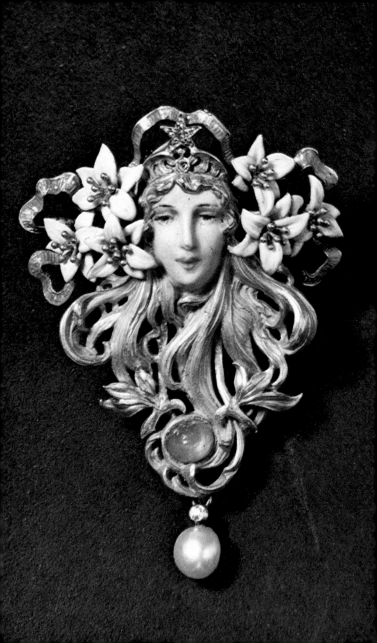

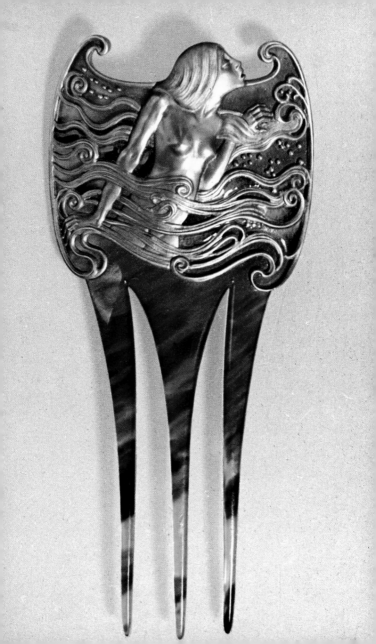

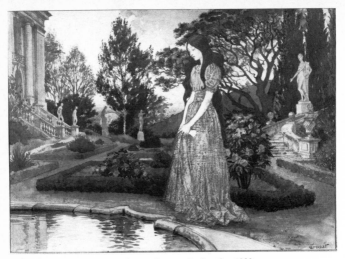

23 Eugène Grasset, *Jeune femme dans un jardin.* Ca. 1900

In Bourgeois's pastel-colored *project de papier* (fig. 25), flowery ornamentation pulsates with unbroken rhythm. It is as if the artist had taken some decorative fragment from a vase, a piece of furniture, or jewelry, liberated it from its setting, and repeated it endlessly in a new, flowing pattern. In these wallpapers, ornamentation is understood as being something uniquely individual and an end in itself; it is this conception that determines the composition of the whole surface. The independent aspect of ornament is equally important in the *reliures* of Henry Jolly (fig. 27) and Alphonse Mucha.

The influence of Japanese art is clearly evident in the designs and objects of art nouveau. However, something quite novel emerged because of the way that Oriental and European elements were combined to constantly produce new and different results. This is particularly apparent in French art nouveau ceramics. All artists were familiar with Japanese pottery and stoneware. This knowledge led, on the one hand, to the creation of simple, unadorned vessels that do not belong to the floral variant of art nouveau and, on the other, to highly decorated, plantlike works.

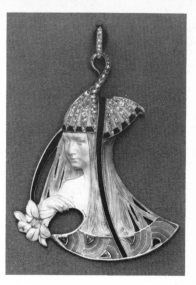

24 Henry Vever, Pendant. 1900

25 Bourgeois, Wallpaper designs. 1901

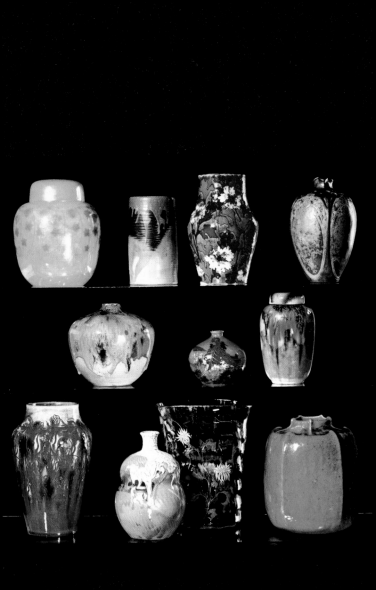

Albert Dammouse, the son of a sculptor, was a major representative of the second group. In addition to works finished with a highly polished glaze, Dammouse created masterpieces of *pâté-decor,* in which the pattern is created by a process of layering, as in enamel work (fig. 26). Auguste Delaherche combined his polished glazes with simple, natural plant motifs that are often obscured by the heavy liquid glaze (fig. 26). Emile Decoeur and Edmond Lachenal painted their faience pieces with Japanese-inspired leaf and bird motifs (fig. 26). All these artists exhibited their works through Bing in Paris. Another member of this group was Georges de Feure, a man of many talents who designed furniture, silver, and tapestries as well as extraordinarily tasteful pottery and stoneware. Among his works are vases decorated with an elegant, almost graphic design (figs. 28 and 29). In contrast are works whose decoration consists of sculpted designs molded when the material was still hot. The pure asceticism characteristic of Far Eastern vessel forms, the unadorned beauty of which lies solely in the gleaming quality of the various glazes, provided models for several masters of the "Grand Feu": Auguste Delaherche, Ernest Chaplet, Edmond Lachenal, Paul Jeanneney, and Jean Carriès. All these artists strove to create works of dynamic vitality through shape and glaze alone (fig. 26).

The close relationship between plasticity and ornamentation is revealed in Raoul Larche's sculpture of the dancer Loie Fuller, in which the folds of the drapery conceal a candlestick (fig. 30). The twirling curves that characterize the composition are enhanced by the twisting motion of the female body. The human figure itself has become an ornament here. However, it is not isolated but rather determines the shape of the work as a whole. During the art nouveau period, it was common to speak of a "plastic ornament," which is a somewhat contradictory concept, since "ornaments" are generally thought of as flat whereas "plastic objects" take up and

◁ 26 CERAMICS *(from top left to bottom right):*
Ruskin pottery, Vase with lid, 1911; Paul Jeanneney, Vase, ca. 1900; Albert Dammouse, Vase, ca. 1895; Edmond Lachenal and Emile Decoeur, Vase, 1901; Auguste Delaherche, Vase, before 1904; Bernhard Moore, Vase, ca. 1910; Christian Valdemar Engelhard, Vase with lid, 1895; August Delaherche, Vase, before 1894; Jean Carriès, Vase, ca. 1890; Emile Gallé, Vase, ca. 1885; Edmond Lachenal, Vase, ca. 1900

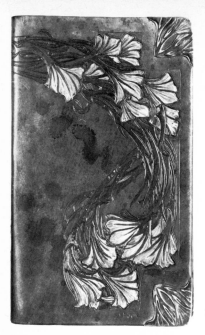

27 Henry Jolly,
Book binding. Ca. 1900

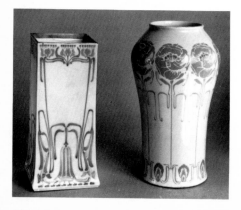

28 Georges de Feure,
Vases. Ca. 1900

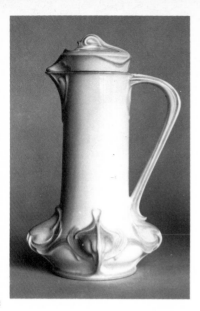

29 Georges de Feure,
Chocolate pot. Ca. 1900

fill space. Loie Fuller was one of the most popular artists' models of
the period, and Larche's sculpture is a graphic illustration of the
"plastic ornament." The "Serpentine Dancer," as Fuller was called
in her day, inspired artists as well as sculptors. The pulsating
ornament that was a central feature of art nouveau can be described
as two-dimensional sculpture or as linearism extended into the third
dimension. Dance is undoubtedly spatial; but the flow of lines
traced by the dancer's body can be thought of as graphic. Fuller's
veil dances were greeted with extraordinary enthusiasm by her
contemporaries. And she was certainly influenced by the art of the
times. Thus Fuller's movements sometimes seemed to create the
impression that one of Gallé's vases had come alive. Like the art
nouveau artists, Fuller also understood how to use color to heighten
the effect of her dances and was the first dancer to work with
colored spotlights. When she danced across the stage covered only
with the thinnest of gauze veils, the almost transparent cloth
glittered like butterfly wings. The seemingly infinite flow of the
veils took on a shimmering ornamental dimension that may well

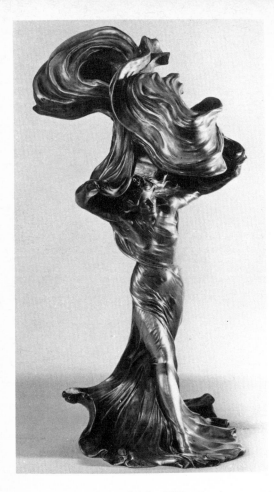

have served as a model for Tiffany's glass creations. Friedrich
Ahlers-Hestermann writes that Loie Fuller, "with her increasingly
daring serpentines, herself became a gigantic ornament. As she
danced, she would seem to light up, burn out, disappear into the
darkness, be swallowed up by the curtain—only to light up again. In
recollection, one might say that these metamorphoses were
symbols of art nouveau itself" (see fig. 31).

◁ 30 Raoul Larche,
"Loie Fuller" lamp. Ca. 1900

31 William H. Bradley,
The Serpentine Dance. 1894

Ornaments do not intrude only into the third dimension; they also conquer the "fourth." This is particularly clear where the dance takes on the ornamental appearance of frozen movement. In such a situation, music becomes a catalyst. It not only awakens feelings but causes the body to move in rhythmic patterns. Musical terminology was frequently used to describe art nouveau creations A line is "furioso," "rhythmic," "contrapuntal." A sketch is "melodious." One feels a "vibrato," "the crescendo of lines," and an "andante surface quality." The relationship between the symbolic paintings of the nineteenth century and music could be expressed, if at all, only through metaphor; the viewer himself had to synthesize the expressive arts. However, the union of art and music during the art nouveau period was expressed in the works themselves: art nouveau ornaments, waving hair, sinewy plantlike growths—all these can be described as graphic equivalents of a musical composition. It is significant that the dance evolved along lines similar to those observed in art nouveau. At first, dancers and choreographers took sheer delight in erotic movement and color. Gradually, these elements diminished in importance in favor of purity, clarity, and true expressiveness.

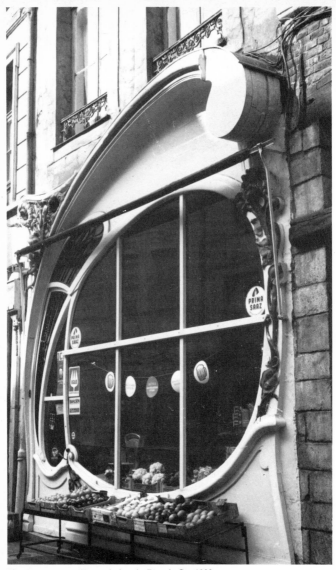

32 Anonymous, Shop window in Douai. Ca. 1900

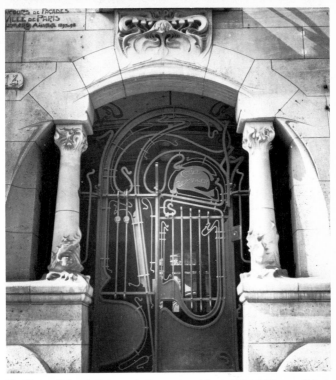

33 Hector Guimard, Entrance to the apartment house "Castel Béranger," Paris.
1894–1897

Wagner's genius, particularly his theoretical concepts, in-
fluenced the art of the turn of the century. The idea of the "total
work of art" *(Gesamtkunstwerk)*, in which music and words unite
with evocative stage sets to produce a single overwhelming effect,
obviously served to stimulate the art nouveau quest for artistic
synthesis.

The astonishing power of a dancer's free leap into the air is
recapitulated in the parabolic curve of a shop window (fig. 32) in
which the framework for the glass panes alone provides a fixed
point for the bold curve of the superstructure. The "leap" is not
completed, however; the movement is frozen into a swirl at the
highest point of the arc. In art nouveau, shop windows were

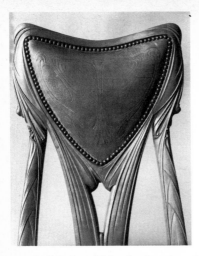

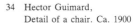

34 Hector Guimard,
Detail of a chair. Ca. 1900

actually "designed" for the first time. The charm of these windows lay in the contrast between spacious and serene glass surfaces and a three-dimensional framework.

Guimard, whose métro entrances caused the stylistic movement of the turn of the century to be known for a time as the *style métro*, must be mentioned once again here.

A work of equal importance is Guimard's Castel Béranger, a luxurious apartment house created between 1894 and 1897. The artist's "floral sensibility," which is manifest in many details of the building, is combined here with a preference for linear curves. The entrance gate (fig. 33) and the staircase railings are excellent examples of this union. The lines of the wrought iron are simple and uncluttered. Guimard completely avoided the tangled knots, dense webs, and fusions typical of art nouveau metalwork. The tension is heightened by the use of individual, overlapping crosspieces. The stairwell is dominated by the rhythmic flow of the ascending line. The railings describe a playful ornamental curve only at the top and bottom. The building complex and the vestibule were designed to produce an effect of harmonious austerity; it can be described as a clearly articulated framework with interlocking membranes. The walls of the entrance hall are treated in such a way as to create the impression of an interlocking, doughlike structure composed of small pieces. Guimard's works stand on the threshold of pure linear

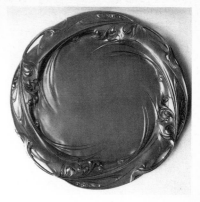

35 Hector Guimard, Plate,
bronze gilt. 1909

36 Jules Chéret,
"Palais de Glace" (poster). 1893

37 Henri de Toulouse-Lautrec,
"Caudieux" (poster). 1893

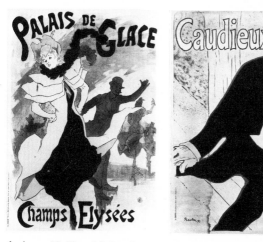

design. Unlike Majorelle's furniture, Guimard's pieces are emphatically naturalistic. Although they contain ornamental swirls, the curvature is simpler and more tense. Harsh angles give way to soft transitions (fig. 34). The line, which always gives rise to an opposing line, causes every object to pulsate with rhythmic motion (fig. 35).

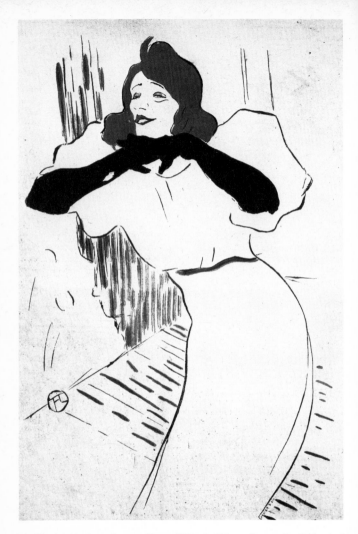

38 Henri de Toulouse-Lautrec, Yvette Gilbert in "Linger, Longer, Loo" (drawing)

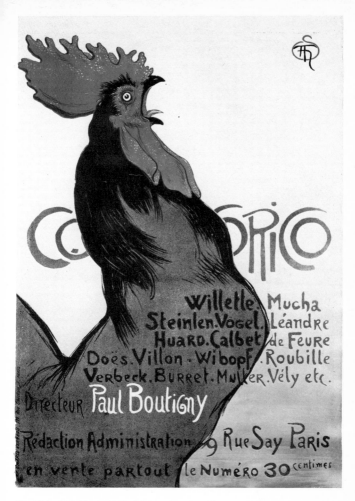

39 Théophile Alexandre Steinlein, "Cocorico" (poster). 1899

The simplification of form and reduction of detail that characterize Guimard's work also dominated French poster art, which became increasingly important as cultural life became more active and economic prosperity increased. The possibilities for duplication, facilitated by developments in the technology of lithography, caused the art of poster illustration to become a distinct graphic subgenre.

Henri de Toulouse-Lautrec, one of the greatest French artists of his day, exerted a decisive influence on art nouveau poster illustration. With the exception of the "pinup girls" that Jules Chéret designed for theatrical performances and music hall shows (fig. 36), Parisian posters were generally modeled on the two-dimensional designs of Lautrec. The poster *Caudieux* (fig. 37) is a typical Lautrec representation of the human form. The outline of the figure is the most important element in the composition. In another poster (fig. 38), the stylized figure, totally devoid of interior sketch lines, stands out starkly from the undecorated background. Lautrec limited his use of color; gradations of black and white contrasted with a few reddish accents give the work its polished finesse. After Lautrec, Théophile Alexandre Steinlein was the leading poster artist of the day. The flat silhouettes of his figures, like those of Lautrec, are sparsely accented with nuances of color (fig. 39). Of all the works created during the art nouveau period, posters in all their variations exercised the strongest, most incontrovertible influence on postwar art.

Brussels

Victor Horta, master of transparent surfaces and rhythmic lines, was a celebrated Belgian architect who combined the elegance of French art works with architectural lightness. Although Horta is always ranked with the best architects of the art nouveau period, the typical and unique elements of his works are more obviously revealed in their small details, which are always thoroughly thought out. In this aspect Horta greatly resembled Guimard. Horta was a true master of the art of ornamentation; he understood perfectly how to give a building ornamental character without directly integrating the decoration into the basic design. His Maison du Peuple (fig. 40), a department store built between 1896 and 1899,

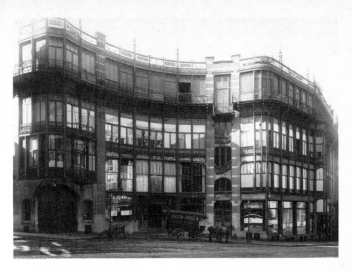

40 Victor Horta, "Maison du Peuple" department store, Brussels. 1899

occupies a special place not only in the architecture of the turn of the century but also in the history of architecture as a whole. This is because it was a direct successor of the bold iron-and-glass constructions of the early nineteenth century. Horta did not actually break with tradition; what he did was to use new building materials in a whole genre of constructions heretofore ignored by artists.

From the beginning of the nineteenth century on, masonry diminished in importance in the construction of bridges, greenhouses, and markets. This is because glass and iron offered better possibilities for bolder as well as more functional solutions. Around 1900, however, architecture began to concern itself with quite different problems. Nevertheless, steel and glass remained as important as ever in France and Belgium, largely as a result of Horta's work. Influenced by the new style, artists and architects sought to blend these materials into a harmonious unity.

The following passage from the *Dictionnaire raisonné de l'architecture française,* written by the great master of iron constructions Eugène-Emanuel Viollet-le-Duc (Paris, 1854–1869), undoubtedly confirmed Horta in his artistic intentions:

77

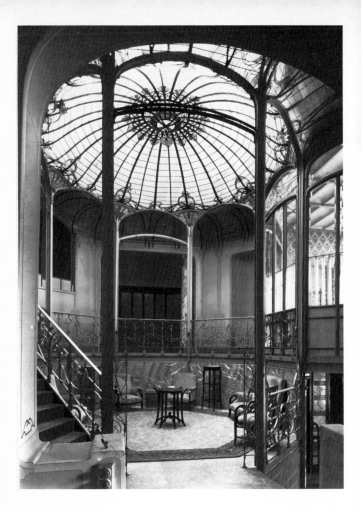

41 Victor Horta, "Hôtel Baron van Eetvelde," interior (hall), Brussels. 1895/96

On the day that people realize that style naturally develops from a specific principle, that style evolves from ideas that obey the logical order of things of this world, that style resembles the growth of a plant which matures according to definite laws, that style is not like some kind of herb plucked from a sack and sprinkled on works that would otherwise lack taste—when people realize this, we will be able to relax in the certainty that posterity will admit that we too had style. Where style exists, architectural form is nothing more than a strict sequence of basic structural principles involving the following problems: (1) the choice of materials to be employed; (2) how to use them; (3) the goals to be fulfilled; (4) the logical development of details out of the whole. . . . One way to recognize style is by observing whether a particular object has been given an appropriate form. If a building quickly reveals the purpose for which it was built, it probably has style; if it forms a harmonious whole with other buildings in its environment, it certainly has style. . . . But why persist in the application of principles? Principles are nothing but honesty in the use of form. Style emerges all the more clearly in works which unambiguously manifest their purpose.

Morta's Maison du Peuple is a perfect example of the requirement that details must be logically derived from the whole. With the exception of bits and pieces of masonry, the façade is composed almost exclusively of glass and iron crosspieces. Although on first impression the building appears to be rather severely partitioned, this arrangement in fact creates an effect of extraordinary lightness and mobility. The individual segments appear interchangeable, almost like dominoes. The transparency of the glass and the delicacy of the crossbeams cause the viewer to imagine that he can open and fold the façade like a fan. There is nothing heavy or ponderous about this building which, in keeping with its function, has been designed with almost Spartan simplicity. The commission of this work as well as the goals that had to be met remain unique in the history of art nouveau. Indeed, one may well ask what there is of art nouveau at all in this "people's store". Its almost mechanical glass-and-iron construction is entirely devoid of ornamentation; the building itself is the ornament. The smooth, unbroken curving lines of the façade can well be regarded as a single large detail. Horta's interiors consummate the union between decorative elements and transparent constructions.

In the lobby of the Hôtel Eetvelde (fig. 41), a glass cupola hovers above the interior like a great ornament blossoming forth from the narrow iron columns that support it. The intertwined branches of this linear system rise upward from the balustrades toward the light that shines through the iron framework hanging over the room. The glass cupola serves to integrate the octagonal room and gives it a feeling of lightness that suggests both the sensation of floating and that of enclosure and limitation. In this regard, it should be noted that the word "cupola" is itself problematic, since one associates this term with something heavy. Perhaps "glass umbrella" or even "glass sky" would be more appropriate. The basic lines of the lobby and cupola are clearly derived from natural forms; one is reminded of algae that assume endlessly varied and intricate shapes in response to the water around them. The door handles of Haus Winssinger (fig. 42) are not the result of abstract linear dynamics; they are, rather, organisms patterned after winding tendrils or trails of smoke. The "Belgian line" had become a fixed concept by 1900.

The new and often extreme formulations were not always the product of unfettered artistic enthusiasm; they were often the result

42 Victor Horta,
 "Haus Winssinger,"
 locks and door handles,
 Brussels. 1895/96

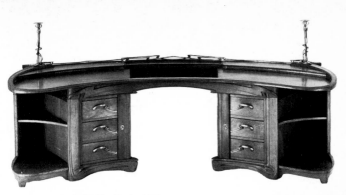

43 Henry van de Velde, Desk. 1899

of careful consideration. Henry van de Velde is a prime example of an artist whose creative process moved in this direction. His significance does not lie so much in his buildings as in his furniture and crafts. Trained as a painter, he belonged to the pointillist school but soon developed his own style and created quite unique and expressive pictures. Always an autodidactic spirit, in 1894 van de Velde built himself a house that soon became a focus of international art nouveau, just as its creator became one of the central figures of the movement. Although he was a great advocate of functional design, van de Velde also understood how to combine purposeful form with lively ornamentation. Moreover, he undertook the creation of a piece of furniture just as enthusiastically as he set about designing a dinner service, a piece of jewelry, or a letter opener. In the interest of ultimate unity, van de Velde attempted to integrate the people living in his interiors into his total conception. Thus he designed clothing to serve as a logical continuation of the line and color of a room. He even created hairstyles for the lady of the house, turning her into a living complement of his artistic conceptions. Van de Velde's creations are easy to identify; for one thing, his intense feeling for ornamentation is always subordinate to his understanding of the purpose of an object, so that decoration and function merge in a harmonious whole. In other words, ornamentation is integrated into a work rather than superimposed upon it. However, the presupposition for this achievement is van de Velde's consistent view of decoration as an inherent part of an

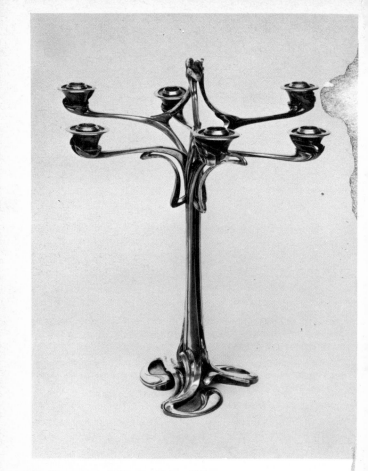

44 Henry van de Velde, Candelabra. 1902

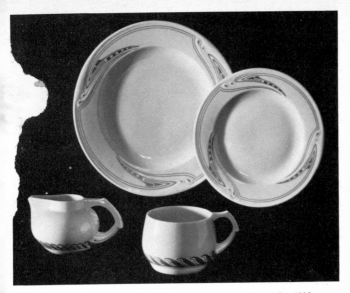

45 Henry van de Velde, Pieces from a Meissen dinner service. Ca. 1905

46 Henry van de Velde, Staircase, Karl-Ernst-Osthaus-Museum, Hagen. 1902

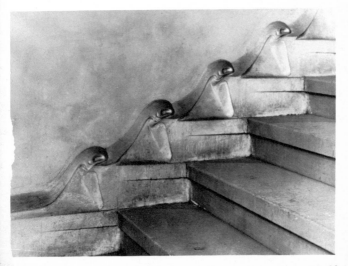

object's function. The desk designed for Julius Meier-Graefe in 1899 (fig. 43) is one of van de Velde's masterpieces. This piece

> wants to be a desk in every sense and to express its purpose clearly. All its parts serve this goal and produce the coordinated effect of a "symphony," which was van de Velde's ideal. Its curved form and the dynamic play of its lines seem intent upon capturing and bringing under its spell anyone who uses it. The desk wants to show the writer that it will support him in his work and that it offers all possible prerequisites for concentration. The piece of furniture is its own promoter, as it were. (Sembach)

In spite of its many sections and compartments, van de Velde's desk evokes a sense of compactness and limitation by virtue of the circular dynamics of its lines. The handles on the drawers, which form part of the total rhythm of the work, stand in contrapuntal opposition to the main lines of the piece. Moreover, slender bands on the two candlesticks at either side of the desk appear to flutter with an almost nervous sensibility. Yet an invisible force seems to lead all the parts to coalesce in coordinated and concentrated movement. This effect is due to the balanced relationship between the smooth, bare surfaces and the interconnected segments.

From Count Kessler's dining room comes a candlestick from the year 1902 (fig. 44), the design of which opens up a whole world of new possibilities for candelabras. The only important thing is that the object must fulfill its function of holding candles. The decorative power of the candelabra is concentrated almost exclusively in the beautiful lines of its arms, which spring up from a slender stem. Van de Velde also designed a dinner service decorated in gold for the Royal Saxon porcelain manufacturer Meissen (fig. 45). The cup and milk pitcher of this service contain a motif that van de Velde had used before on the staircase of the Karl-Ernst-Osthaus Museum in Hagen (fig. 46). The decoration, which is composed along parallel lines, seems to press forward with vigorous urgency. If one gazes at it long enough, one is drawn into the vortex of a veritable whirlpool of ornamentation that appears to set the whole object in motion. The dynamic sweep of the design on the staircase in Hagen anticipates the ascending line of the steps. The plate, cup, and milk pitcher are excellent examples of the union of decoration and function. The handles are ornaments in themselves. The raised sculpted swirls of the design on the plates

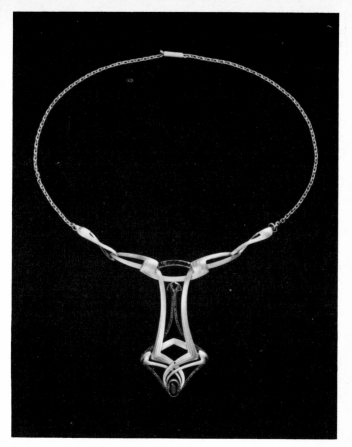

47 Henry van de Velde, Necklace. Ca. 1900

recapitulates the shape of the object as a whole, and we can once
again feel the tension between empty and filled space.

With few exceptions, the art of jewelry design in Germany was
limited to the creation of pleasing works of mass production. By
and large, the pieces were imitations of French and Austrian
models. Nevertheless, the influence of van de Velde's abstract
ornaments was also evident. His jewelry designs breathe with

48 Antonio Gaudí, "La Sagrada Familia," view from the northeast,
 Barcelona. 1884–1926

tension and vitality. What we see is a joyful play of lines as they are
drawn into the orbit of dynamic ornamentation. A necklace set with
precious stones that belonged to the widow of Karl Ernst Osthaus
(fig. 47) is classic in its beauty. In van de Velde's works, the
possibilities offered by dynamic linear shapes were developed to
their fullest. Nothing more can be added.

Barcelona

Antonio Gaudí's strangely expressionistic architecture represented an attack against all previously known principles of construction. Straight lines were denied and hidden. The natural function of balances and supports was concealed from the beholder. Instead of the old rules, imagination held sway; everything was permitted and nothing impossible. Just as Gallé reacted in a typically French way to the new style, so Gaudí incorporated the Spanish tradition. After his death, Gaudí was honored almost as a saint; this can be explained by the situation that prevailed in Catalonia at the time. The Catalonian *Renaiça* demanded political autonomy, since it was here alone in Spain that industrial progress was taking place. In addition, the province of Catalonia was the homeland of a prosperous middle class oriented toward international relations of all kinds. Gaudí's style affirmed this new patriotic independence, and his personality was a reflection of the political sensibility of the region. Gaudí was also deeply religious in the sense of Spanish Catholicism; he was steeped in mystical ideas, which he sought to capture and express in his buildings. His world of forms included all possible types of animals and plants. Although abstract design was foreign to Gaudí, his art was informed with social ideas and had a broad social basis. For example, he built housing projects under the auspices of the Societat Obrera Mataronese, a cooperative workers' association.

The most unique feature of Spanish art as opposed to that of northern countries is its Moorish influence. Since Arab art and architecture are characterized by an absence of human representations, artists were forced to turn to ornamentation as the only permissible form of decoration and to perfect it. Europe and Africa unite in Spain, where incredible works have been produced over the course of centuries. The history of Spanish art is filled with paradoxes. Spanish Gothic, for example, is a true hybrid in which mystical and spiritualized forms stand in dialectical opposition to the dynamism of a purely decorative creative urge. One sees walls covered with a dense tangle of branches in which pointed Gothic arches and the leaves of cruciferous plants become lost. Although a kind of textile pattern emerges, it is one in which the weave can neither be discerned nor unraveled. The cult of the saints, which was practiced only in sequestered isolation, gives way to dreamlike

87

49 Antonio Gaudí, "Casa Milá," roof structures (chimneys),
 Barcelona. 1905–1907

50 Antonio Gaudí, "Casa Milá," Barcelona. 1905–1907 ▷

states of mystical irrationality. Spanish inwardness and abstraction,
drawn into the vortex of banal passions, undergo transformation
and lead to an ecstacy that destroys the body.

This is the tradition in which Antonio Gaudí found himself. His
early works include palaces and villas; however, Gaudí's late years
were dedicated exclusively to the construction of the otherworldly
Sagrada Familia (Temple of the Poor), a church that was built
through collections and endowments alone (fig. 48). Gaudí's bold
solutions are combined with a great luxury of forms and wealth of
materials. A tremendous variety of costly elements were incor-
porated into Gaudí's works. Architecture was regarded as
sculpture; façades were kneaded, as it were, until the eye of the
beholder could no longer identify the individual elements. The
ornamentation works its way from inside out and from the ground
floor to the spires. Gaudí's preference for plantlike ornamentation

was pushed to its extreme. The churning dynamism of the entire structure captivates the viewer even if the forms are so exalted as to leave him breathless and confused.

Gaudí's architecture is characterized by experiments with colored segments. He often clothed apparently independent architectural elements in colorful ceramic tiles which, in turn, seem to produce the effect of independent added decoration. The suggestion of straight lines is avoided. The tiles consist of interlocking fragments; this arrangement has the effect of exaggerating the artist's attack upon traditional architecture (fig. 51). On the other hand, the asymmetrical tendency and amorphousness of Gaudí's designs are concealed by some added labile element. Everything is in motion. No other artist of the art nouveau period matched this Catalonian individualist in eliciting highly picturesque critical comparisons: "flamboyant extrava-

gance," "architecture like the curved back of a salamanderlike saurian," "labyrinth," "dune formations," "dried foam on the beach," "hollow dream constructions," "elongated beehives," "gigantic plant stalks," "sugar loaves," "stalactite caves leached from water," "mushrooms," "spiral loops."

Gaudí reworked traditional stylistic elements without succumbing to historicism and imitation. Because of the extreme position he took, it seems miraculous that he produced such a lasting effect upon the architecture of expressionism. In his book *Die Architektur des Expressionismus,* Pehnt praises Gaudí highly and evaluates his work in considerable detail, describing him, however, as an architect and not an artist of the art nouveau style:

> Critics have overlooked the fact that Gaudí succeeded—without 'crutches' and without buttresses—in breaking through the autonomy of weights and supports in a construction that obeyed the laws of mechanical force. In order to achieve his goal, he subordinated the entire structural organism to a creative will that was strong enough to ignore traditional principles of construction. The support system of the viaducts in Parque Güell, the crypt in Santa Coloma, and the Sagrada Familia in Barcelona were completed partly with the aid of technical drawings and graphic representations, partly through experimentation on a model, and partly through improvisation on the spot. Gaudí's intuitive responses, shaped by experience, determined the building's statics. Since the process of construction demanded an infinite number of spontaneous decisions, one can say that the design was not conceptualized at the beginning of the project but only upon the completion of the work. . . . Crassest naturalism and bold subteties are found in both Gaudí's early and late works. Throughout his entire career Gaudí loved to combine heterogeneous materials: freestone, which was reworked until it lost its original identity; bricks, wrought iron, colored and white glass, tiles, ceramics, and in Parque Güell (1900–1914) the most improbable articles, such as propellers and dolls' heads! Gaudí made a cult of the ugly and produced a number of examples reflecting this sympathy, as did his pupils. He went much further in this direction than did the architects of central Europe, who were unable to free themselves from centuries of dedication to the concept of harmony. Gaudí was an individualist through and through. Although he did not really belong to the art nouveau movement as such, he was related to the artists of this period. Yet he was also superior to them; he passed beyond the horizon of central European art nouveau and also beyond that of expressionism—his was an architecture of action, a happening.

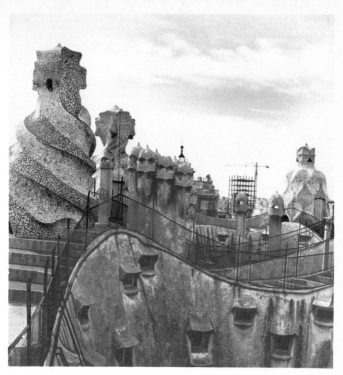

51 Antonio Gaudí, "Casa Milá," roof structures, Barcelona, 1905–1907

Around 1900 Gaudí, with his Casa Milá (fig. 50), succeeded in creating an architectural work free from all historicism and conceived entirely as sculpture. The basic outlines of the building show a total avoidance of straight lines. The rooms flow into one another uninterrupted by flat surfaces. The spherical façade resembles a waterfall. The functional principle has clearly been rejected. The columnar supports and the ledges framing the windows are sculpted and represent a continuation of the entire façade's flowing curvature. The artist's sculptural intentions triumph in the plastic objects perched upon the roof (figs. 49 and 51).

London

England is regarded as the homeland of the entire art nouveau movement. In fact, as early as the eighteenth century, a fantastic art replete with mystical thematic images had developed in England. On the other hand, art nouveau as it evolved on the continent never truly appeared in England at all. Rather, English artists were pathfinders and precursors of the new style. What is very important, however, is that genuine social consciousness first took root in England. This revealed itself in an idealistic rejection of privilege and the production of luxury objects for a single protected class in favor of a fairer distribution of mass-produced goods for a larger sector of society.

William Morris, the leader of the revolutionary art movement in England, furnished his home in 1857 with furniture that could almost be called primitive, so puritanically austere were the pieces. Even his friends the Pre-Raphaelite painters regarded the furniture with mockery and amazement. "To them the tables seemed as immovable and colossal as cliffs, while the chairs evoked the sense that Barbarossa had sat in them." (quoted in Ahlers-Hestermann)

Morris's ideas and work were not free of historical influence; in fact, the opposite is true. For Morris, the Middle Ages represented the last epoch in which unbroken unity and harmony could be found. It was his goal to mediate the intellectual and spiritual concepts of the medieval world to his own age and to revitalize them without regard for the historical environment. To this end, he rejected all machinery and relied solely on manual fabrication. Indeed, machines were rejected and held in contempt in all the workshops that were founded as a result of his influence, e.g., in the firm of Morris, Marshall & Faulkner (1861), in C. R. Ashbee's Guild School of Handicraft (1888), and in the Arts and Crafts Exhibition Society (one of the most important associations for the promotion of artistic handicrafts). The English reform movement of the nineteenth century took place mainly outside the big cities, since Morris regarded the city as inimical to art and nature. This attitude led to an extreme naturalism that often focused, however, on the enigmatic and obscure. The English products were "sophisticated" in the highest degree. Numerous individual "artist-designers" waged war against ugly industrial products, each

52 Charles Robert Ashbee, Silver goblet. 1902

working independently of the others and also outside the framework of Morris's and Arthur Mackmurdo's Century Guild. For these artists, as for Morris and Mackmurdo, the applied arts and crafts were as important as the fine arts of painting and sculpture. It was Mackmurdo's express goal to "remove all branches of art from the control of merchants and to restore them to artists." The Guild's aim was "to revitalize architecture, decoration, glass, painting, ceramics, wood carving, and metal work." In 1898, in an article for *The Art Journal,* Walter Crane issued a demand "to turn our artists into craftsmen and our craftsmen into artists." This concept had increasing influence on the continent during the last quarter of the nineteenth century. It clearly shaped the programs of the various schools, studios, and societies that were subsequently founded.

Of primary importance was the Arts and Crafts Movement represented by the Arts and Crafts Exhibition Society, which was founded in 1883 and united in its membership a whole series of individual voices and stylistic orientations. The individual personality of the particular artist retreated into the background in this organization. It was no longer the creation of new forms that was decisive; of primary concern was, rather, a new understanding of

arts and crafts and the subordination of creative activity in this sphere to the unifying principles of simplicity, functionality, and realism.

Linear movement is particularly visible in the works of the architect and designer Charles Robert Ashbee. Ashbee's silver goblets can be regarded among the finest works of the entire epoch (fig. 52). The preeminence of the line, which was characteristic of art nouveau in general and represented an adaptation of natural forms, may have led to a loss of vitality and power in Ashbee's works. However, as we can see in Ashbee's goblet, this loss was more than compensated by an increase in elegance. A certain atmosphere of understatement radiates from these wonderful, precious objects. Although at first sight they present themselves to the viewer as cool and reserved, they clearly reflect spiritual depth. In fact, they are the work of an esthete who betrayed his own principles in their execution. Ashbee's goblets are too refined and too highly cultivated to have found resonance in a broad population totally uneducated in art and lacking artistic sensibility.

The products of the firm of Liberty, founded by Arthur Lathenby Liberty in 1875 with the advice and help of his friend William Morris, still reveal the unbroken tradition of the English silversmith's art. However, established tradition is united with the ultrarefined stylistic sensibility of the British variant of art nouveau. The success of these objects was such that art nouveau in Italy came to be known simply as *lo stile Liberty*. These articles usually have a graphic quality and smooth surfaces. Although the lines are gentle, simple, and economical, they are complemented by mysterious, delicate, stylized, ornamental flowers perched upon the slenderest of stalks, which breathe with a life of their own. Harmony of color, which was so important to art nouveau artists, is realized here through the subtlest gradations of tone. Silver is frequently mixed with mother-of-pearl. The blue-green-violet tones of liquid enamel radiate with aristocratic self-confidence (fig. 54).

The architect Charles Francis Voysey (1875–1949) by and large rejected ornamental decoration in his geometric, tectonic buildings. His smooth façades, which are divided by elegant rod-shaped structures, are reminiscent of the productions of the Wiener Werkstätte. A strong Japanese influence, however, distinguishes Voysey's work and gives it a unique place in English architecture.

94

53 Aubrey Beardsley,
 The Death of Pierrot. Ca. 1900

His textile and metal designs, with their vivid floral patterns, resemble French art nouveau; yet in their clear coloring they are distinctly English products.

The leading representative of the Arts and Crafts Movement was Arthur Mackmurdo. Mackmurdo played an influential role in founding the Century Guild in 1882. His floral patterns, which appeared on wallpaper, furniture, and curtains, were derived from a careful observation of nature. Mackmurdo's works contain numerous traditional elements which he combined with his favorite theme, rhythmically pulsating plant stalks.

Aubrey Vincent Beardsley, whose life was veiled in scandal, was a favorite child of the declining nineteenth century. Beardsley was the master of linear art nouveau and influenced all of Europe with his striking, almost exclusively black-and-white illustrations. In Paris, Puvis de Chavannes and Henri de Toulouse-Lautrec belonged to his circle of admirers as early as 1892. Beardsley's artistic individuality and creative power were so great that he was able to absorb and synthesize the most diverse influences—from that of the Italian Renaissance to orientalism and the art of

Japan—without sacrificing his own originality. Beardsley met William Morris when he was only nineteen years old, and it is clear that the young artist was influenced by Morris's unique use of clear lines to create a dense, intricate web of flowers and figures. Yet each artist finally found the other's work alien and Morris was greatly irritated by Beardsley's frivolous drawings (fig. 54). In his conceptions of art, Morris pursued an ideal that was in diametrical contrast to Beardsley's "carpe diem" philosophy. English book illustration of the 1890s was dominated by a belief in the "power of the line." Beardsley belonged to this tradition, and the newly discovered technique of reproducing line etchings coincided with his artistic requirements. The figures in his illustrations appear as stark and plain as letters in an abstract framework. These characters, which are always sharply separated from each other, are formed by a continuous sharp line which, despite the movement suggested, appears to have been chiseled and carved. Beardsley wrote:

> I am anxious to say something somewhere on the subject of *lines* and line drawing. How little the importance of outline is understood even by some of the best *painters*. It is this feeling for harmony in *line* that sets the old masters at such an advantage to the moderns, who seem to think that harmony in *colour* is the only thing worth attaining.

Regarded solely from the perspective of graphic design, Beardsley undoubtedly belonged to the art nouveau movement. However, the content of his drawings brings him closer to the symbolists. In his work we see a refinement of desire, taste, luxury, and pleasure—all things to which he gave himself over heart and soul and which were manifest in his friendship with Oscar Wilde and in his illustrations for the latter's books. It is these elements that place him in the symbolist movement. However, it must be

54 ARTS AND CRAFTS *(from top left to bottom right):*
Louis Comfort Tiffany, Favrile glass, ca. 1905; Cymric, Liberty , & Co., Desk clock, 1902; Gabriel Argy-Rousseau, Small vase, after 1900; Louis Comfort Tiffany, Round vase, ca. 1900 (see fig. 90); Cymric, Liberty and Co., Bowl, 1902; Cymric, Liberty and Co., Covered box, 1902; Charles Muller, Vase, ca. 1900; Louis Comfort Tiffany, Favrile glass, ca. 1905; Charles Schneider, Table lamp, ca. 1900; Jan Eisenloeffel, Covered box, ca. 1900; Louis Comfort Tiffany, Favrile glass, ca. 1904; Antonin Daum, Layered glass, 1898

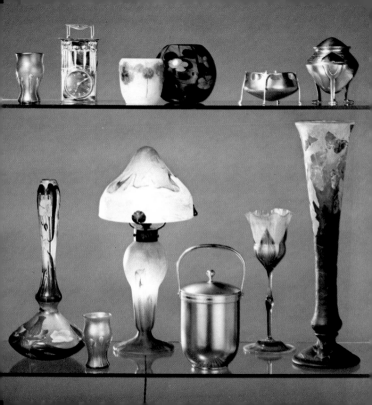

remembered that symbolism itself evolved out of the expressive form of art nouveau. Arthur Symons wrote: "Beardsley is the satirist of an age without convictions, and he can but paint hell as Baudelaire did, without pointing for contrast to any contemporary paradise. He employs the same rhetoric as Baudelaire, a method of emphasis which it is uncritical to think insincere."

The painter, illustrator, and craftsman Walter Crane had become known as early as 1865 for his innovative pictures for fairytale books. Crane loved to render the unreal quality of art nouveau in fanciful sketches. The requirements of art nouveau were realized in quintessential form in Crane's painting *The Horses of Neptune* (fig. 56), even though purely graphic elements are, perhaps, of even greater importance in achieving the total effect. The omnipotence of nature is not revealed in amorphous formations, as in Gaudí's work, but rather through mystical similes. A fantastic scene saturated with symbolic power stretches out before us in an unbroken continuum of motion that can neither be dissipated nor broken down into components. The frenzied animals burst the bonds of the painting's framework and have a sculpted quality. The wave motif reveals a spiritual kinship with similar Japanese graphics. However, in contrast to Japanese art, in which motion is esthetically restrained and flatness is emphasized, Crane allowed nature to come alive and break the fetters imposed upon art by traditional rules.

Glasgow

At the periphery of the English movement, a group of Scottish artists were at work in the city of Glasgow. These artists succeeded in synthesizing and reformulating the new style that had been experienced and realized by their neighbors to the south. In so doing, they traveled down paths already trodden by British artists but not yet fully explored by them. To this group belonged the architects Charles Rennie Mackintosh and Herbert McNair and their wives, the McDonald sisters. Mackintosh was the leading figure of the "Glasgow group," and by 1890 had already developed his cubic style. By dividing and organizing space into a series of squares and rectangles, he produced a compact but stately effect. The austerity of his architectonic structures is relieved by delicately

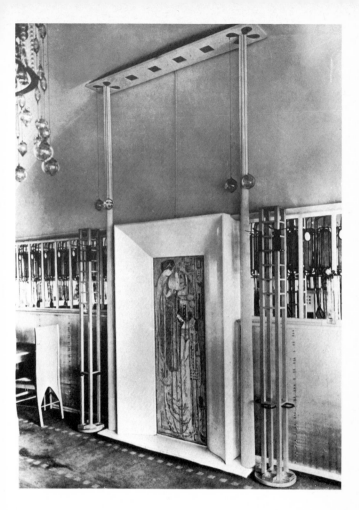

55 Charles Rennie Mackintosh, "Willow Tearoom," Glasgow. 1903–1906

56 Walter Crane, *The Horses of Neptune*. 1892

curved linear ornaments drawn across the many vertical lines like a
strangely stylized web of water lilies. It is only when this trelliswork
is cast aside that one recognizes the elemental boxlike structure that
is typical of Mackintosh's creations.

The sources from which Mackintosh and the other members of
the Glasgow group drew inspiration were the same as those that
inspired the artists of the Arts and Crafts Movement in Britain:
Japan and the Pre-Raphaelites.

As in Japanese art, Mackintosh's point of departure was flat
ornamentation. A labyrinthine interlocking of separate segments
creates a flat, ornamental appearance that seems devoid of
decorative elements. With great insight, Mackintosh understood
how to bind together all the elements and individual details of a
piece of work so that the austere, boardlike character of his

furniture and buildings was softened by ornamental "knots" and joinings. Surfaces, doorknobs, and window bars are harmoniously derived from the underlying background. The influence of Japanese art is evident here and helps to give Mackintosh's designs their insular character. In summary, it is the well thought out, economical detail of Mackintosh's work that gives his pieces their esoteric charm.

The McDonald sisters preferred more figurative ornamentation. Their basic conceptions and selection of individual motifs can be traced directly back to the Pre-Raphaelites. Their elongated, delicate figures joined in an interplay with nonobjective forms have the stylized appearance typical of works produced toward the end of an artistic movement. Their figures seem spectral in quality, scarcely able to lift their tiny, segmented heads. Everything about

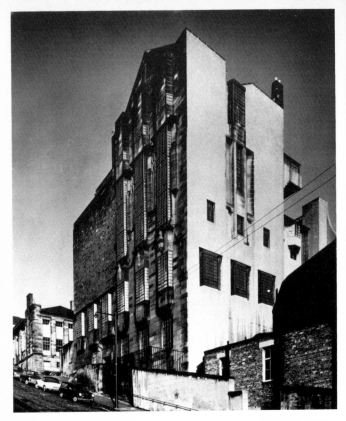

57 Charles Rennie Mackintosh, Glasgow School of Art, Glasgow. 1897–1899

them seems ornamental: the folds of their clothing, the flowers in
their hair and hands. These extremely delicate symbols of
femininity float across pieces of furniture, wallpaper, and
tapestries. They are executed in metal as well as in mosaics made of
jet and tin. At first sight, one would be hard pressed to find any
point of relationship between these works and Mackintosh's
tectonic structures. However, the relationship is, in fact, extraordi-
narily close (fig. 55). The system of the figures, their curved

102

posture, and the striped linear bands of their clothing were simply transformed by Mackintosh into nonobjective ornamentation. The effect of the McDonalds' figures is paralleled by the overlapping vertical lines and general composition of space characteristic of Mackintosh's rooms. His interiors, down to their artistic flower arrangements, have an aura of fragile unreality. Chandeliers are formed of dense networks of pearl-decorated cords that seem to give off faint music. Mackintosh's use of color is also striking. His furniture is generally painted white or stained black. He used pastel tones such as pink, pearl gray, ivory, or pale green for the decor. In his predilection for light colors, Mackintosh resembled van de Velde and the French glass artists. As was true elsewhere, color was not used simply to give greater definition to an object; liberated from the object, color became an independent medium for self-expression.

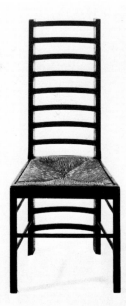

58 Charles Rennie Mackintosh,
 "Willow Tearoom," chair.
 Glasgow, 1904

It is difficult to describe the specific features of the Glasgow style without referring to symbolistic tendencies. It would be forced and unjustified to place Mackintosh and his group alongside the symbolists. However, it cannot be denied that their linear networks stimulated the imagination and that the rhythmic motion of their work evoked certain moods.

> In art nouveau, the arabesque has become a universal gesture filled with artistic expressiveness From the perspective of form, Ernst Michalski has articulated the concept of the "complementary line": every line produces its opposite, just as every movement produces a countervailing motion that results in an arc that never seems to come to rest. From the perspective of its symbolic content, the leap expresses a particular mood *(état d'âme)*. This "spiritual leap," as it were, can be captured in form through the sweeping flow of a line. The ideology of art nouveau is contained in the rhythm of the arabesque. The arabesque becomes a form through which the world is experienced. (Hofstätter, *Symbolismus*)

Mackintosh experienced space in terms of dynamic lines, and it is this perception that makes his work so unusual.

The compact, blocklike style of the Glasgow School of Art building gradually gave rise to a new, sober concept of architecture (fig. 57). The subtle charm of broken surfaces against a solid background gave way to geometric severity. No architect was able to produce in more perfect a form than Mackintosh the refined atmosphere of Scottish tearooms. A wooden chair designed by Mackintosh in 1901 (fig. 58) is almost unusable. The high back is uncomfortable and its height would probably create a disturbing effect if the chair were allowed to stand freely in a room. One can see by looking at this piece of furniture that the effect intended can only be realized in association with the setting for which it was designed. The rectangular composition of the chair's back reflects Mackintosh's conception of the appearance of things; this element is comparable to a partitioned wall. This perception is one-sided, however. In spite of the economy of Mackintosh's construction, the chair comes close to being stylized, frozen in an attitude of complaisance.

By 1903 the Glasgow group had lost its importance. Nevertheless, its effect on the development of modern architecture is incontrovertible.

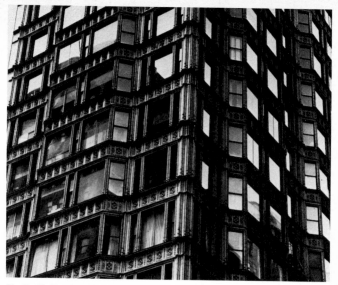

59 D. H. Burnham & Company (collaborator: C. B. Atwood),
 Reliance Building, Chicago. 1894

Chicago and New York

It is not easy to set up a connection between art nouveau as it was
realized in America and the parallel stylistic movement in Europe.
The architect Louis Sullivan and the glass artist Louis Comfort
Tiffany evolved styles that were not only independent of each other
but that also differed from European formulations. Admittedly,
the ornamentation found on Sullivan's buildings shows typical
features of art nouveau. (It was no accident that Owen Jones's
Grammar of Ornament appeared in America precisely in the year
1888.) This type of ornamentation had its roots in England and can
be traced back to Morris's tendrils as well as the tangle of bands and
ribbons characteristic of Celtic works. Although this ornamenta-
tion is graceful and elegant, it totally lacks the dynamic abstract
power of contemporary European examples. The structural
simplicity and scaffoldlike structure of Sullivan's buildings had a
lasting influence on the architecture of succeeding generations. The
Chicago department store of Carson, Pirie, Scott & Co. anticipated

the skyscrapers of the twentieth century. Even without the added ornaments, the cubic design would have established itself. The proliferating metal frieze that adorns the ground floor is recapitulated in the somewhat more abstract window frames decorated with geometrical forms. Burnham and Root's basic architectural conception of a totally undecorated yet dynamically curved building comes closest in form to European art nouveau (fig. 59).

Tiffany's strength and his influence on European artists was due less to specific decorative elements than to the elegant use of line in his unique glass works. We will discuss Tiffany and his works in detail in a separate chapter.

Line also dominates the graphics of William Bradley, a Chicago artist who was clearly influenced by Beardsley and Toulouse-Lautrec. His *Serpentine Dance*, a depiction of Loie Fuller (fig. 31), is a graphic variation of a Tiffany vase. As observed earlier, all areas of arts and crafts merged together during the art nouveau period. The primacy of a dynamic, vital, and indestructible line provided a unifying principle.

Vienna

In 1864, the Austrian Museum for Art and Industry was founded for the sole purpose of initiating a reform in the industrial production of arts and crafts, an industry that had expanded beyond all expectation. This museum sought to realize its pedagogical goals by promoting the Renaissance style, which was regarded as a model for all branches of art—an approach that led to the stylistic limitations inherent in historicism. Thus it is not surprising that a violent counter reformation developed by the late 1890s, not only in Vienna but throughout all of Europe. The new reformers sought guidelines in modern life and not in imitation of earlier styles. The architect Otto Wagner demanded a "naissance," not a "renaissance." In 1897, Wagner joined together with other avant-garde artists to form an association called the Secession. A year and a half later, the group opened an exhibition hall designed by the young architect Josef Maria Olbrich. The group's motto appeared on the building for all to read: "To Time Its Art, to Art Its Freedom." As

elsewhere, the "total art work" was the ideal. Arts and crafts were to be set free and synthesized with interior decoration and the fine arts. This synthesis was meant to express human existence in its totality and to call forth a new perception of life. The soft, fluid style of the Secessionists was enormously popular. Their preference for pleasing lines and lively decorative elements (suggestive of delicate tinsel) led, of course, to a commercialization of this style. True mass production set in, to the great dismay of some of the group's leading artists, such as Josef Hoffmann, Koloman Moser, and Gustav Klimt.

Around 1900, after the World's Fair, Austrian arts and crafts experienced a genuine triumph. The success of these products was promoted by the Museum for Arts and Crafts in every possible way. No one recognized the danger that inevitably lurks in the endless repetition of successful designs. In 1901, Josef Hoffman invited Mackintosh's Glasgow group as well as members of various English workshops to Vienna for a Secession exhibition. Subsequent return visits deepened the comradely relationship among these artists. Hoffman finally realized, as did Moser, that these international relationships could provide a new impetus and a point of departure for better work. Thus Hoffman went to England, where he became acquainted with Ashbee's workshop principle. Ashbee worked in London's East End, where he employed many young craftsmen as his assistants. Ashbee himself created the designs, which were then executed under his supervision and ultimately sold directly from the workshop. The profits were evenly distributed. Influenced by English principles and designs, the Secessionist style, which was heavily charged with feeling and emotion, became simpler, more functional, and more realistic. Geometric patterns were increasingly used to decorate surfaces, while strict harmony prevailed in room design and interior decoration. Everything harmonized—from flowerpots and banisters to furniture, carpets, wallpaper, and small household articles. For these items, Moser, who was gifted with a prodigious imagination, constantly found new forms.

In May 1903, Hoffman, Moser, and Fritz Wärndorfer decided to found a new communal workshop. Wärndorfer had returned from England inspired by Ashbee's studio and was ready to give the project the necessary financial support. In June 1903, the commune was registered under the name of the Wiener-Werkstätte-Produktiv-Gemeinschaft von Kunsthandwerken in Wien (The Viennese

Productive Workshop Society of Craftsmen of Vienna). By 1905, a little brochure appeared whose exquisite format prepared the reader for ambitious works. The brochure stated that Hoffmann and Moser were responsible for the artistic direction of the association and that they were to be the sole designers of the gold, silver, and metal objects, bookbindings, leathercrafts, and furniture to be produced. In spite of the range of objects, however, the group regarded the building and furnishing of houses as its main task.

As the Wiener Werkstätte gained in importance, the significance of the Vienna Secession diminished. This was partially due to internal discord. In 1905, a permanent schism occurred. Gustav Klimt, Otto Wagner, Emil Orlik, Alfred Roller, Karl Moll, Josef Hoffmann, and Koloman Moser left the group, which in its last years increasingly served the interests of industry and trade and thus lost its position as the primary representative of Austrian arts and crafts.'' The Wiener Werkstätte, whose strivings for unity and purity found recognition and support in intellectual circles of middle-class reformers, thus became the most important representative of the art of craftsmanship.'' (Catalogue, *The Wiener Werkstätte—Modern Arts and Crafts from 1903–1932,* May 22–August 20, 1967)

The penetration of art into life was the goal these artists and craftsmen sought to realize, and their workshop fervently dedicated itself to this reform. Numerous exhibits were organized. In 1907, a theater and cabaret called Fledermaus was founded on the Kärntnerstrasse in accordance with plans drawn up by Josef Hoffmann. Modern forms of entertainment that fitted in perfectly with the modern and elegant environment were nurtured here. The design of the theater was carefully planned, down to the last detail. Although the function and purpose of the establishment were never forgotten, the theater nevertheless radiated decorative charm. Other outstanding buildings created by the artists of the Wiener Werkstätte were the Pukersdorf Sanatorium, still a prototype of modern architecture, and above all the Palais Stoclet in Brussels (fig. 60). The Palais Stoclet, a total work of art built between 1905 and 1911, was not only one of the group's most important creations but one of the most perfect buildings produced anywhere in Europe during the art nouveau period. Indeed, in designing the Palais

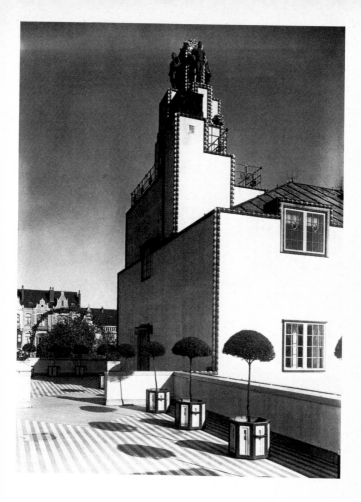

60 Josef Hoffmann and the Wiener Werkstätte,
 "Palais Stoclet," garden terrace and tower, Brussels. 1905–1911

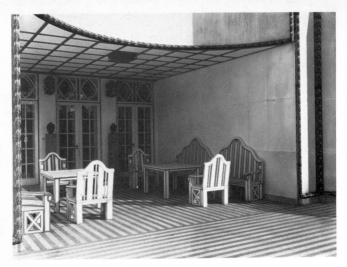

61 Josef Hoffmann and the Wiener Werkstätte,
"Palais Stoclet," veranda, Brussels. 1905–1911

Stoclet, the Viennese artists succeeded in endowing art nouveau with one of its most beautiful and lasting memorials.

In the "final" year of the art nouveau movement, the Belgian industrialist and art collector Adolphe Stoclet commissioned the palace that was to become world famous. Stoclet had lived in Vienna for a long time, and it was there that he found an architect whose conceptions coincided with his own ideas. That architect was Josef Hoffmann. Stoclet commissioned Hoffmann and the other artists of the Wiener Werkstätte design the palace and complete its interior and exterior decoration. Thus was realized the dream that art nouveau artists longed for: a total work of art was conceived and born. The basic design of the Palais Stoclet—a simple rectangular structure—is overwhelmingly beautiful and supremely orderly. Blocklike individual parts appear as if placed one on top of one another or one behind the other. Horizontal and vertical lines dominate the total effect. However, the cubic impression is softened and indeed yields to a feeling of restful flatness. This effect is produced by slabs of white marble covering the wall (fig. 61). The marble seams are emphasized by gilded bronze strips that also serve to unify the various parts of the room. The somewhat ponderous

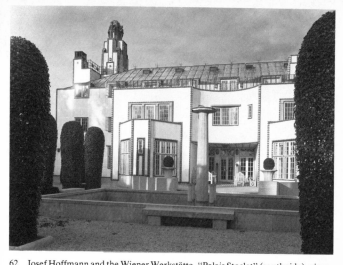

62 Josef Hoffmann and the Wiener Werkstätte, "Palais Stoclet" (south side), view of the garden and pool, Brussels. 1905–1911

tower, which is reminiscent of the Darmstadt school, does not detract from the lightness of the building, which seems cheerful and serene despite the costliness of its materials. The confident self-assurance that manifests itself in the grand but graceful proportions of the exterior is recapitulated in the impressive sequence of the individual rooms. The two-story pillared reception hall is flooded with brilliant white light. As on the outside of the building, each panel is joined to the next by ornamental strips. The chairs and sofas upholstered in a black-and-white striped pattern obey a cubist principle. In spite of its lavishness, the "palatial" effect of the building is understated. Its basic lines suggest openness and form a continuum with the adjoining park, in which nature has been subordinated to geometric principles. The trees are pruned into rounded shapes and, along with the full rear façade of the building, are reflected in the calm waters of a pool. Reality and reflection join together to form a monument to the perfect beauty of the straight line (fig. 62).

This house, created without financial limitations, is a celebration of harmony and unity in detail and furnishing. It is a triumph of the artist's love for decorative elements, flat design, and noble straight

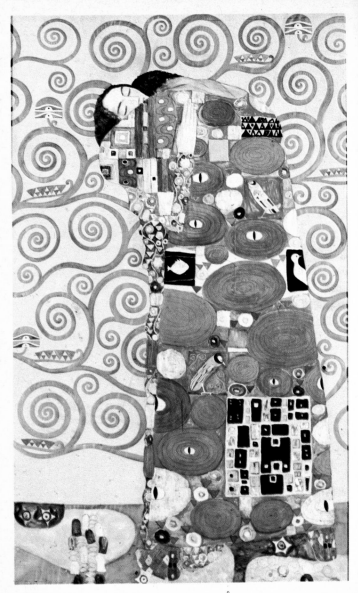

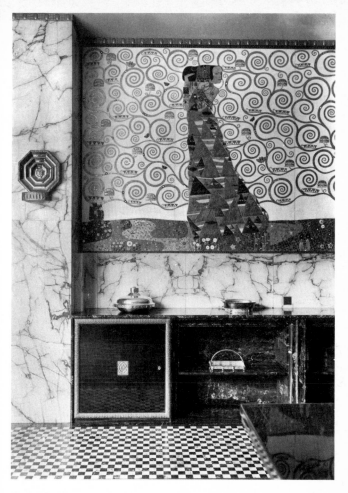

64 Josef Hoffmann and the Wiener Werkstätte, "Palais Stoclet," large dining room with wall painting by Gustav Klimt, Brussels. 1905–1911

63 Gustav Klimt, *Fulfillment*. Ca. 1909

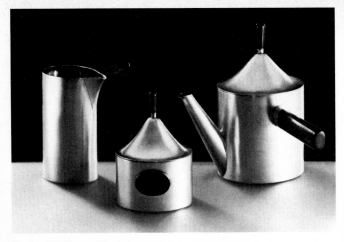

65 Josef Hoffmann, Pieces from a silver service. Ca. 1905

lines. The whole work can be regarded as a decorative program in which the architect has paid tribute to the laws that shape a perfect ornament.

Gustav Klimt, Vienna's most important painter, was commissioned to create wall mosaics for the interior rooms of the Palais Stoclet (fig. 64). Murals were Klimt's favorite form of self-expression. (Between 1900 and 1903, he completed the painting cycle *Philosophy, Law, and Medicine* for the assembly hall of the University of Vienna, and the freedom of expression he allowed himself there caused a scandal.) Klimt's paintings, flat and ornamental, do not attempt to achieve a spatial effect. As in the winged, multipaneled altarpieces of the fifteenth century, the ornamental elements in Klimt's paintings (for which he, like his predecessors, used gold leaf and foil) are entirely independent of the content of the painting. Klimt's figures are positioned asymmetrically in his compositions. Superimposed above figures of geometrical simplicity and starkness are countless small decorative forms juxtaposed with naturalistic shapes suggesting parts of the body. *Fulfillment* (fig. 63) is reminiscent of a collage. As in Munch's work, the theme originates in the realm of feelings. One of Klimt's most famous pupils was Oskar Kokoshka, who paid homage to his

teacher by dedicating to him an illustrated volume of poems entitled *Die träumenden Knaben (Dreaming Youths)*.

Josef Hoffman was not merely the creator of works that expressed the glorious end of a stylistic sensibility on the verge of disappearing forever; he also created objects whose simple balance makes them models of modern design in general (although their costliness is such that they harmonize perfectly with other elements of the Palais Stoclet). The pieces of a silver service with ebony handles designed in 1904 are representative of Hoffmann's forward-looking style (fig. 65).

The Wiener Werkstätte remained active until 1932, when this enterprise was dissolved for financial reasons. As long as it functioned, the studio represented the best that Austria was producing in the way of art in all its branches. Within the framework of this group, Josef Hoffmann was able to realize the full range of his creative ideas and was also able to express his social views. In 1905, Hoffmann published a program of works and activities that reveals the scope of the workshop principle as well as the influence of this concept of production on modern design.

The first catalogue of the Wiener Werkstätte appeared in 1905. The list of its activities was probably completed by Josef Hoffmann and Koloman Moser. In its wording and content, the catalogue clearly reveals the enthusiastic exuberance and reforming spirit of young artists at the beginning of our century.

Excerpt from the "Work Program of the Wiener Werkstätte"

> The terrible havoc being wrought upon the applied arts by inferior-quality mass production on the one hand and mindless imitation of old styles on the other is coursing through the world like a gigantic stream. We have lost contact with the culture of our forebears and are being pulled apart by a thousand new desires and considerations. Instead of using our hands, we use machines. Not the craftsman but the businessman is important. It would be insane to try to swim against this stream.
>
> Nevertheless, we have founded our workshop. Here, on our native soil and in the midst of the cheerful noise of creative productivity, it should provide us with some measure of peace and tranquillity. It should be welcome to anyone who agrees with the ideas of Ruskin and Morris. We appeal to everyone who finds this sort of culture valuable and hope that our inevitable mistakes will not cause our friends to cease supporting us in our goals.

Otto Wagner, the Austrian architect and senior building advisor, was a cofounder of the Vienna Secession. Yet Wagner's work does not belong among that of the group described above. Wagner was one of the reflective, cerebral artists of the turn of the century whose numerous writings laid the foundation for modern architecture. Two of his pupils became leading architects of Viennese art nouveau: Josef Maria Olbrich and Josef Hoffmann. In 1895, Wagner published his seminal book *Moderne Architektur,* in which he wrote:

> The simple, practical, one might almost say military manner of looking at things that characterizes our age must be fully expressed in an art work, if art is to serve as a faithful mirror of our times When it comes, the artistic revolution will be so great that it will be wrong to speak merely of a renaissance of the Renaissance. A completely new birth will be necessary; the result of this movement will be a "naissance"

Nevertheless, Wagner's earliest buildings are not entirely free of historical influences. However, although their ancillary structures create a classical impression, the basic design has been carefully worked out with an eye toward purpose and functionality stripped of decorative elements. One of Wagner's main works, the façade of an apartment house on the Wienerzeile (1888–1900), is covered with colorful majolica tiles that reveal the art nouveau artist's love for colored architectural elements. The cupolas on Wagner's church in Steinhof, on the outskirts of Vienna, reveal the monumental building style characteristic of Byzantine architecture. The Postal Savings Bank (fig. 66) in Vienna shows Wagner's predilection for innovative building materials; however, he only employed these if they served to realize an artistic idea. The courtyard of this building is a large glass hall subdivided by delicate metal rods. The total effect is one of lightness and suspended calm. The façade is structured along strictly axial lines. Symmetry and flatness dominate, reflecting Wagner's wish for harmony and an absence of dissonance. In order to soften the severity inherent in monumental architecture, Wagner superimposed a network of small, geometric decorative elements—a typical feature of the art nouveau works of the Viennese school. The crowning superstruc-

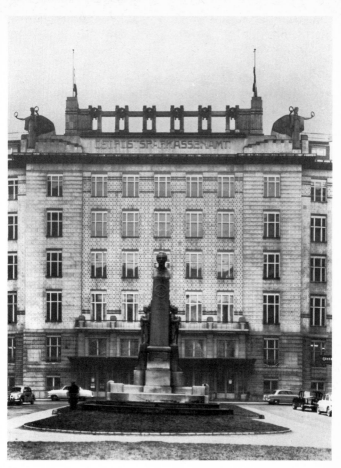

66 Otto Wagner, Postal Savings Bank, Vienna. 1905

ture with its wreath-bearing angels represents an affirmation of contemporary historicism. Wagner did not always succeed in producing an organic unity between his functional constructions and the decoration then so much in demand. However his forward-looking ideas remained vital and influential. His almost revolutionary insistence "that the only point of departure for modern art should be modern life" enables us to understand and recognize the impulses that motivated his work: democracy, rationalism, and technology. But Wagner qualified his assertion:

> The primary idea informing any design is not determined through statistical and mathematical calculation; one recognizes it by sensing its natural appropriateness. The right form becomes apparent to the artist through a process of discovery. Viewed from this perspective, architecture crosses the threshold into art. The architect must select, complete, or discover the construction that coincides best with his conception and also lends itself best to becoming a work of art. The available materials and the purpose of the object to be created always cause a tension to arise between the limits of total utilitarianism and the goals of artistic realization. The correct balance must be left to the discretion of the individual artist or engineer.

Although the Wiener Werkstätte were to some extent inspired by mathematics, there was another group that regarded bare unadorned surfaces as the sole creative principle. This group was influenced by Ruskin's view that articles designed for everyday use should be devoid of ornamentation. Adolf Loos was the spokesman of these artists. Feeling himself challenged by contemporary Austrian solutions to the problem of ornamentation, Loos published a paper entitled *Ornament und Verbrechen (Ornament and Crime)* in 1908. The title speaks for itself. Loos's main service to art did not lie in his exaggerated invective against ornamentation. On the other hand, he did recognize that art nouveau had fettered creative activity by imposing a one-sided esthetic demand for a *Gesamtkunstwerk*. The subordination of all objects to one creative principle ultimately destroyed the artistic self-determination that must alone shape any object expected to acquire lasting form.

67 Hans Schmithals, *Composition*. Ca. 1900

Munich

The situation in Germany was relatively less clear and coherent than that in Austria or France, where a single predominant orientation shaped the stylistic tendencies of the movement as a whole. Art nouveau, it will be recalled, was characterized by two variants, one floral and the other almost abstract. These two styles did not coexist but flourished and evolved separately, only occasionally meeting and intermingling. In Germany, the turn of the century was experienced as a romantic era, full of illusion; there was much less hedonism and worldliness than in Paris. People felt close to nature and were also ready to undertake reform.

Art nouveau in the form of "nature romanticism" first appeared in Munich, where this variant persisted the longest. The style was characterized by a flatness or two-dimensionality that emphasized the underlying surface. At the same time, designs breathed with dynamic vitality and motion. As in Austria, industrialization had steered arts and crafts onto a self-destructive course. The historicism propagated by the academies was mindlessly translated into mass-produced articles for everyday use. This was the lamentable situation into which the Munich Secession was born. In 1892, a group of artists joined together in the common belief that art should concern all humanity—indeed, that art itself affected everyone. Thus realism and functionality merged with ethical

119

68 Hermann Obrist, *Whiplash* (wall hanging). Ca. 1895

considerations. The Munich artists took themselves very seriously; this is clearly revealed in their numerous programmatic and theoretical writings. These publications have stood the test of time and present a number of convincing arguments that still appear quite modern. The ideals of the Munich group are concisely expressed in the following excerpt from Hermann Obrist's *Zweckmässigoder Phantasievoll (Functionality or Imagination)*.

> We all know that popular arts and crafts can only be regarded as healthy if their forms are simple, honest, practical, and unequivocally suited to their use. We also know that everyone, but especially artists, must take part in resurrecting this lost ideal. Our critics are wrong when they accuse us of overusing the term "popular art" to describe this ideal. They are also wrong to believe that we view "popular art" in the democratic sense of something cheap and utilitarian, and that we are hostile toward anything that is costly and imaginative. With all due respect to "popular art" in its democratic sense, "art" is something altogether different. Art, by which I mean not only painting and sculpture but also handicrafts and architecture, and especially the art of transitional periods which nourished and inspired man for centuries—such art ceased hundreds of years ago to be popular in a modern and democratic sense. On the contrary, art has long since

69 Hermann Obrist, Model for
a monument. Ca. 1895

become a luxury of the highest order, both from a material and a psychological point of view Only when man learns how to unify his aristocratic and democratic feelings, only when he has learned how to accept costly things as a psychological and material cultural necessity, only then will he be able to correctly assess the value of the imaginative craftsman who wants to express more than mere functionality in arts and crafts.

Hermann Obrist was the most brilliant spirit of the highly creative Munich group. The son of a Scottish noblewoman and a Swiss doctor, he originally studied medicine and the natural sciences. From the beginning, Obrist was a passionate observer of tropical flora and fauna. During his student days at Heidelberg, while he was taking a walk, Obrist experienced the first of the great visions that were to inspire him to become an artist:

An entire city appeared before him as if out of thin air. It surpassed anything he had ever seen and was also quite unlike anything he knew about. Everything was in motion; streets drew aside to reveal squares with fairytale fountains; houses opened up to reveal inexpressibly beautiful rooms and mysterious objects. (As recounted by Schmutzler)

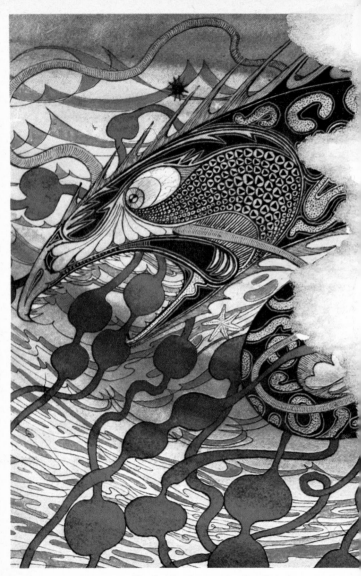

70 Carl Strathmann, *Attacking Fish*. Ca. 1890

123

71 August Endell, "Atelier Elvira," façade, Munich. 1896/97

Obrist had his first successes with ceramics and furniture at the
World's Fair in Paris. He arrived in Munich in 1895 by way of
Berlin, Paris, and Florence. By this time, he had also developed his
talents as a sculptor. In designing the fairytale-like Elfenzug
fountain, Obrist concluded that nothing new could be expressed in
the human form. He therefore turned his attention to more limited
forms. Together with Berthe Ruchet, his mother's former
companion, he founded a studio for embroidery in Munich,
drawing inspiration for his embroidery designs from music. And
indeed, his works suggest musical compositions in graphic form. In
1896, Georg Fuchs described the artist's celebrated wall hanging
Whiplash of 1895 (fig. 68) in an article published in *Pan:*

> The frenzied movement of the design calls to mind the stark, powerful
> curve of a cracking whip. The associations vary. The design sometimes
> seems to be a reflection of some mighty elemental force of nature such
> as lightning. At other times, we are forced to think of some great man,
> a conqueror, perhaps.

72 Richard Riemerschmid,
 Pottery jug. Ca. 1900

73 Peter Behrens, Crystal goblet.
 Ca. 1910

This piece of embroidery can be regarded as a symbol of the entire Munich movement around 1900. Alpine violets were the principal motif of the piece, yet Obrist did not limit himself to reproducing a natural phenomenon. Rather, he transformed nature into fantastic images of immense evocative power. Obrist's work is an expressionistic outpouring of nature in all its vitality and with all its superabundance of form. Straddling the borderline between symbolism and ornamentation, between abstract dynamics and the representation of a specific organism, Obrist created a visual metaphor for the pulsating, surging energy of life itself (see also fig. 69).

Obrist's fantastic ornamentation found intensified expression in the wild spherical vortices that swirl across Hans Schmithal's compositions (fig. 67) like primal, elemental forces such as flickering flames or rushing geysers. Carl Strathmann's almost ludicrous pictures (fig. 70) reflect the tension that exists between painting, arts and crafts, and graphics. The façade of the Atelier Elvira (fig. 71), designed by August Endell, is a further example of

German art nouveau. The façade of this studio is dominated by a flamelike, tension-charged ornamental shape that seems to float across the flat surface of the wall. The wall itself seems to have lost its traditional function of providing support and suggests to the viewer that it, too, has been captured and swept along in the decorative flame. The aggressiveness of the movement reflects the artist's own aggressive feelings toward dead, sterile historicism in design. The glaring colors of the ornament are consciously tacky and were meant as a deliberate assault on bourgeois taste. This aggressive principle of design was continued in the interior of the studio, where the phastasms of the building's exterior were reproduced on the walls and stair railings. Endell, who had originally studied philosophy, was extremely versatile, as were all the significant artists of the art nouveau period; he designed furniture, carpets, textiles, and jewelry. In his later works, the sweep of an ornament became increasingly large, encompassing the whole building and determining the sequence of its interior rooms as well. Endell himself provides us with the clearest insights into his work and his floral sensibility. The following excerpt is taken from his *Um die Schönheit (On Beauty):*

> We have been overcome by ecstacy, a kind of madness. Joy threatens to choke us. Unless a person has experienced this, he cannot understand visual art. If one has never been enchanted by the lovely curves of a blade of grass, the marvelous mercilessness of a thistle, the reserved, virginal quality of a budding leaf, if he has never been gripped by the luxuriant tangle of a root formation, the intrepid vitality of a bursting fruit, the slender grace of a birch tree, the superlative calm of a cluster of leaves—if none of these things has touched the viewer's soul, he can know nothing of the beauty of forms.

Twenty-seven years after the first international art exhibition took place in the Crystal Palace in Munich, thirty artists returned to this city once again; among them were Obrist, Bernhard Pankok,

74 ARTS AND CRAFTS *(from top left to bottom right):* ▷
Lötz-Austria, Luster glass, ca. 1900; Royal Saxon Porcelain Works, Meissen, Gravy boat, ca. 1900; Engelbert Kayser, Cookie tin, 1902; Johann Julius Scharvogel, Small vase, ca. 1905; Hans Christiansen, Drinking glasses, ca. 1900; Hans Schwegerle, *Amourous Faun* (sculpture), 1902; Engelbert Kayser, Candelabra, ca. 1900; Richard Riemerschmid, Pitcher, ca. 1910; Michael Povolny, *Spring* (porcelain sculpture from a series of the Seasons), 1908

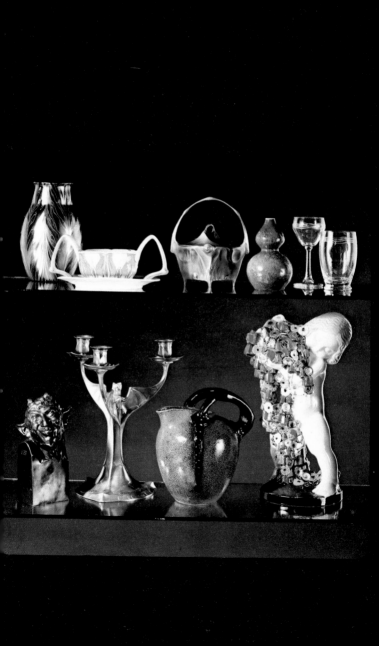

Richard Riemerschmid, Endell, Otto Eckmann, and Peter Behrens. These artists established the United Workshops for Arts and Crafts, which took their direction from English models. It was also the group's goal to obliterate the distinctions that separated fine art from applied art. Pankok was the antipode of the group, which was otherwise oriented toward principles of functionality and realism. His furniture revealed the influence of art nouveau in its almost classical abundance of inventive detail. In their basic conception, Pankok's pieces resemble the sculpted effect of Majorelle's works. For Riemerschmid, on the other hand, "the technical, architectural experience" was all-important. However, structural inspiration was combined with the artist's profound love for the folk art of Upper Bavaria, and the two elements merged to give rise to a unique, inimitable style. Riemerschmid created numerous stoneware vessels characterized by sparse decoration. The roundness of a jug (fig. 72) itself becomes a simple and dynamic ornament that is in perfect harmony with the function of the object. Riemerschmid's interior decoration, which took into account all aspects of human life and its concomitant necessities, was exemplary.

> In this room, a new kind of eating was necessary. In a room like this, one has to sit differently. New movements and new kinds of conversation arise. This leads to new forms of social relationships, indeed, to a new kind of society altogether . . . in which the stiff dignity and conventionality of the old generation are gone, replaced by a younger generation that is forward-looking and dresses in sporty clothing. A man is a gentleman but not a company director. He has intellect but has cast aside the title of professor. This style promotes a new kind of intellectuality and a new kind of class system. (Kurt Bauch)

Riemerschmid created his most unified work in the construction of the Munich Chamber Theater.

Peter Behrens, who was called to Darmstadt in 1900, was probably the most "modern" member of the Munich group. Originally trained as a painter, he met all the requirements demanded of the new craftsman. Behrens was equally secure as an architect, sculptor, graphic designer, book illustrator, calligrapher, and glass artist. His graphics are clearly influenced by Japanese models and produce a reserved and elegant rather than a floral

75 Thomas Theodor Heine, "Devil" (poster). Ca. 1895

76 Bruno Paul, Caricature from
Simplicissimus. 1901

effect. Behrens combined an almost ascetic estheticism with a
search for new forms. His later works clearly reveal the dominant
influence of the "construction principle" as described above. In
1907 Behrens became an artistic adviser to the AEG (Allgemeine-
Elektrizitäts-Gesellschaft—The General Electric Company) in
Berlin. Thus we have the example of a man who made the complete
transition from being an artist for the elite to becoming a designer of
high-quality objects for everyday use (fig. 73).

Like Riemerschmid, Bruno Paul, the seventh member of the
United Workshops, also knew how to blend all the elements of an
interior into a coherent unit. Paul's furniture is indissolubly linked
to the room for which it was designed. The room itself is
characterized by an absence of sharp angles, edges, and seams even
where a wall is paneled in wood. His arts and crafts evolved from
the timeless basic forms one sees in the utensils used by peasants. In
his graphics, which are of extremely high quality, he repeatedly
represented the people of his Upper Bavarian homeland (fig. 76).

77 Ernst Neumann,
 "The Eleven Executioners"
 (poster). 1901/02

Johann Julius Scharvogel's and Max Laeuger's ceramics are also in
keeping with the tradition of local crafts (fig. 74).

Otto Eckmann became famous for his "Eckmann type," a new
and influential form of lettering in which the letters seem to draw
the background into a field of tension created by their curving lines
rather than to lie flat against a background surface. The interplay of
background and central motif, which is a dominant element in
Eckmann's graphics, reveals some of the problems that were to
arise in later abstract painting.

Other artist's groups were established in addition to the
influential United Workshops. In 1899, a group called Die Scholle
was formed. Leo Putz, its most typical representative, described
the goals of this group as follows: "Without 'Die Scholle' I would
have become a miniature painter; we broke our backs trying to raise
the poster into an art form." The best posters in Germany came
from Munich. Their striking effect resulted from the achievement
of a perfect harmony between the lettering, linear representation,

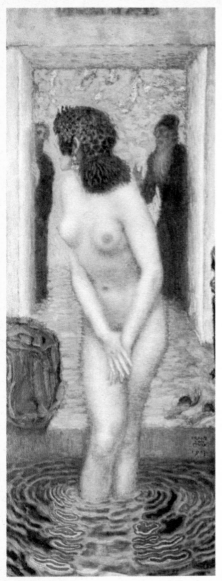

78 Franz von Stuck,
 Susanna at Her Bath. 1913

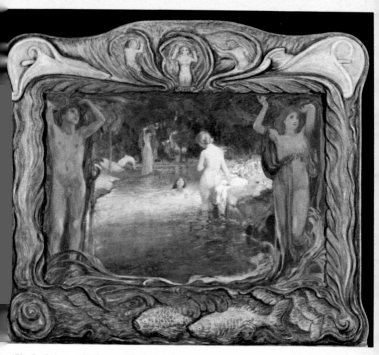

79 Ludwig von Hofmann, *Idyllic Landscape with Bathers*. Ca. 1900

and ornamental background (fig. 77). Ludwig Hohlwein and Thomas Theodore Heine (fig. 75) were the creators of the modern art of poster design, which is still alive today.

The group called New Dachau was guided by the same spirit that prevailed in Die Scholle. Their spokesman was the painter Adolf Hölzel, who described the art of this group as follows: "A flat form is a flat surface demarcated and limited by lines. Good design can always be produced by using the simplest flat forms—circles, ovals, triangles, rectangles—as a point of departure. These forms need not remain strictly geometrical, however."

Franz von Stuck, a true native son of Munich, did not belong to any of the existing groups. This "artist prince", who was enthusiastically honored in his own lifetime, had already developed

133

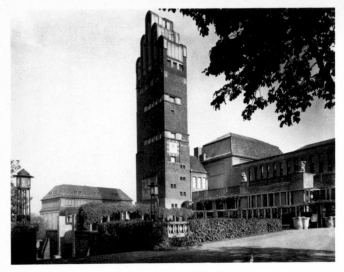

80 Josef Maria Olbrich, "Wedding Tower," Mathildenhöhe, Darmstadt. 1901–1908

his own language of forms—derived by and large, from a mystical inspiration. Von Stuck regarded himself primarily as a painter; his architectural activities were limited to the design and construction of a single large house. His social connections were largely responsible for spreading the popularity of art nouveau in Munich and for enabling this style to gain both prestige and popularity. Von Stuck had an innate ability to predict taste; he was thus able to produce works that inevitably became very popular. His paintings are related to symbolist works, yet they lack the esoteric depth and profundity that characterized the peculiarly French, Belgian, and Dutch creative process and led artists from these countries to claim symbolism as their own. Von Stuck's female figures are "wicked" and have an exotic charm. He knew how to combine naturalistic representation in the foreground with abstract surfaces in the background; it is precisely in this union that the art nouveau style is revealed (fig. 78).

Like von Stuck, Ludwig von Hofmann began as an academic painter. In a formal sense, he belonged with the impressionistic landscape painters. His arcadian figures move through springtime

settings that exude an atmosphere of imperturbable serenity. In 1892, von Hofmann became a member of The Eleven in Berlin, a group that was united by its opposition to the formalism of Wilhelmine painting. Von Hofmann's uniqueness lay in his ability to integrate the frame of a picture with its central themes and motifs by a process of selective recapitulation. In his *Idyllic Landscape with Bathers* (fig. 79), the central theme is repeated in condensed and symbolic form in the frame. Wavy lines and fish are used to symbolize the water of the stream, while lilies and shell-like ornaments duplicate the female figures in symbolic form.

Darmstadt

In addition to Munich, which was a particularly fruitful center of art nouveau, a German art nouveau tradition also took shape in Darmstadt. In 1899 the last Grand Duke of Hessen, Ernst Ludwig, decided to form a colony of young artists. This bold idea ultimately led to Darmstadt's emergence at the forefront of art nouveau as it was developing in Germany. Within a single decade, architecture underwent a complete transformation. Ernst Ludwig of Hessen brought together art nouveau artists not only from all over Germany but from Austria as well. The founding of his colony was not unlike the founding of groups elsewhere. However, the founding of the Darmstadt commune illustrates the variety of motivations that caused like-minded spirits to come together; indeed, the English workshops were a far cry from the almost baroque commissions of the Grand Duke of Hessen. Admittedly, the desire for reform and regeneration animated Ernst Ludwig with the same force as it did Ashbee, and with the same purity. Nevertheless, the environment that gave rise to his group was vastly different from that in which the English communes were born, as were the conditions that allowed the Duke to realize his ideas. In contrast to England, where kindred spirits came together to form a commune, the wish to found the Darmstadt group sprang solely from the person of the Grand Duke, who also planned the way the studio would be built, chose its site, and was the sole source of money. His "artists' colony" on the Mathildenhöhe was like a private army. The works produced in this colony were no less

excellent because of the way in which the group was founded. However, the group uniquely symbolized the collapse and reformation that characterized the turn of the century: on the one hand, a group of artists lived and functioned in the advanced social form of a commune; on the other hand, the commune was sponsored by an aristocratic patron.

The first task facing the members of this group was to create a living space that would complement their working space. Because of the total nature of this commune, in which its members lived as well as worked, a unique architectural structure was required, one that would differ substantially from the studios and exhibition halls built by other groups. Ernst Ludwig chose the site, the Mathildenhöhe. On this hill, a new architectural style evolved to correspond to a new lifestyle.

A tall building that could be seen from afar ultimately towered above this center of art. When it was completed, it looked like a hand that both commanded attention and served as an exhortation. This remarkable structure, called the Wedding Tower (fig. 80), bears an inscription that can be regarded as a motto for the entire Darmstadt project: "Respect the past but have the courage to dare something new. Remain true to your own nature and to the people you love."

Josef Maria Olbrich, one of the cofounders of the Vienna Secession, was called to Darmstadt in 1899 by the Grand Duke. He was not only the principle architect but also the dominating intellect of the community. Olbrich had been a pupil of Otto Wagner, the leading architect of Vienna; his ideas and works were greatly influenced by his teacher. It is perhaps symptomatic of the Darmstadt group that Olbrich, the outsider from Vienna, became the model for Erich Mendelsohn, the most popular exponent of expressionist architecture in the 1920s. Olbrich's buildings, which often bring to mind images that are utterly foreign to architecture and alien to the basic function of buildings, are possessed of an almost visionary power. The Darmstadt Wedding Tower is like a modern work of sculpture. Olbrich also created a design for a studio on the Mathildenhöhe—a building that looked like a throne standing close by a supporting wall. The exhibition hall for two-dimensional art designed for the same project looks more like a transatlantic steamer than a room, partly because of its decorative,

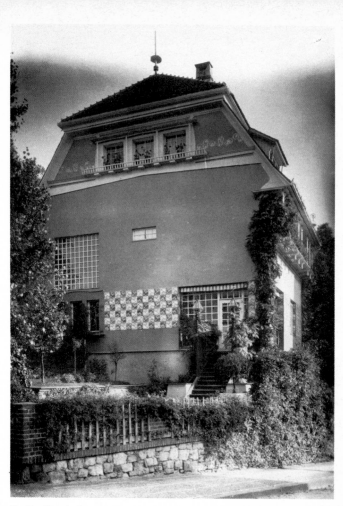

81 Josef Maria Olbrich, The artist's house, Mathildenhöhe, Darmstadt. 1901

82 Josef Maria Olbrich, Soup spoon. 1901

quasi-nautical forms. Olbrich's predilection for this type of
keel-shaped arch gave his buildings a forward thrust. This is clearly
revealed in the house he built for himself in 1901 on the
Mathildenhöhe (fig. 81), a structure that represents a perfect
synthesis of flat surfaces and rhythmic motion. Like many other
contemporary architects, Olbrich also designed articles for
everyday use. A soupspoon (fig. 82) he designed in 1901 repeats at
the bottom edge the grooved curve that serves to join the ladle and
the handle. Olbrich's intention was to make entirely visible the
construction problem involved. Had it not been for his death at a
relatively early age (in 1908), Olbrich would most certainly have
joined Peter Behrens and van de Velde after World War I in leading
a new generation of artists inspired by cubic forms and functional
design.

In 1901 the Darmstadt group organized an exhibit entitled "A
Document of German Art." This exhibition was not intended to
represent only the products of a particular group; rather, it was
supposed to mirror an ideal community and way of life. Thus the

138

83 Peter Behrens, Entrance to the artist's house,
Mathildenhöhe, Darmstadt. 1901

colony itself became the object of the exhibit. Darmstadt, that
mecca of the arts, was stamped by Olbrich's highly personal style.
Even Peter Behrens, who arrived from Munich, could not
modulate the dominating influence of the Austrian architect.
Olbrich's blocklike buildings stand in the service of function and
largely renounce ornamentation and symbolism. Peter Behrens,
for whom the ornament was an essential component of the whole,
was opposed to the purity and clarity of Olbrich's forms. In his own
house in Darmstadt, however, Behrens conformed to the overall
concept of the colony and was able to synthesize linear and abstract
form. However, small details on the building, such as the front
door, reveal Behrens's love for decorative detail and ornamenta-
tion (fig. 83).

The Netherlands, Finland, and Norway

These centers of art nouveau exerted their influence not only upon
the artists of Europe but also upon those of the American
continent. The unique national characteristics of these countries
blended with the dominant characteristics of art nouveau, infusing
and shaping its floral, linear, and cubistic styles.

Two totally different groups emerged in Holland. On the one
hand, the ornate, stylized art nouveau line appears in countless

Dutch works; at the same time, other Dutch works manifested their creators' strong desire for pure form, a goal that already contained the germ of a new realism. The ornamental curves of Jan Toorop's painting *The Three Brides* (fig. 86) reveals the autonomy of a line whose calligraphic rhythm bears no relationship to the content of the picture but instead creates its own independent design. The surface of the painting seems to be covered with a textile pattern upon which fluttering locks of hair, arched bodies, folded robes, and swinging bells all unite to form a linear tapestry. Toorop was born in Java, and features indigenous to that island mingle with mystical and lyrical elements in his pictures. Prior to Toorop's conversion to Catholicism in 1905, his works revealed a painful tension between Far Eastern superstition and the artist's personal desire for salvation through Christ. In *The Three Brides*, a heavily veiled human bride surrounded by roses stands between the bride of Christ and the figure of a vampire. Incense—or the curling trails of incense smoke—surrounds the scene.

The art of the Far Eastern colonies became generally known throughout the Netherlands. Jan Thorn-Prikker's pictures, for example, suggest the steamy atmosphere of the jungle. Exotic ornamental motifs, orchids, and peacocks adorn the porcelain produced by the Rozenborg factory in the Hague (fig. 18). The outlines of the vases designed by Juriaan Kok seem to suggest female genitalia—a characteristic feature of "physiognomic symbolism" (fig. 18).

In spite of foreign influences, Dutch art nouveau remained unsentimental and somewhat severe. Hendrick Petrus Berlage, a leading Dutch architect of the time, expressed a point of view that was modern, cool, and objective: "Money buys everything, even art. The more money, the more art. And now comes the fatal confusion of cause and effect: if something costs a lot of money, it must be art" Berlage made this observation in 1906, on the occasion of a lecture delivered to the members of the Krefeld Museum. Like Morris, he attacked capitalistic thinking, which set up its own standards as those by which everything, including artistic creativity, was to be judged. Berlage believed that architecture was based on logical principles of construction and sought to apply these principles to all spheres of artistic creativity. Although in this regard he was perhaps less energetic than the other reformers of his

84 Jan Eisenloeffel, Brass utensils. Ca. 1910

generation, he was more severe than his contemporaries in
attacking the stylistic potpourri and confusions of the nineteenth
century. "Not one chair, not one table, not a single pot is
satisfactory. The only reason why these objects do not drive us to
distraction is that people, unfortunately or perhaps fortunately, can
get used to anything." For Berlage, a work of art had to be
convincingly related to the artist's social theory. His Amsterdam
Stock Exchange was completely liberated from the constraints
imposed by historical imitation. The block-shaped form of this
building, in which all the separate elements were drawn together by
the tension of the surfaces, clearly reveals its structural principle.
Berlage promoted the calm, classical style reminiscent of Greek
temples. His buildings were intended to transcend the particular
historical period of their genesis and to exemplify the architect's
wish to create works of social and artistic integrity.

In addition to Berlage, the silversmith Jan Eisenloeffel was also a
staunch supporter of art nouveau in its austere variant. Eisenloeffel
created simple, solid, and practical articles mostly of brass and
decorated with only a few etched lines. His boxes, cans, and cups,

85 Edward Munch, *The Shriek*
(lithograph). 1895

designed in the simplest and most practical shapes, became models for modern household articles (fig. 84). Eisenloeffel's silver articles also stressed craftsmanship and simple geometric lines. He demonstrated that strict form and elegance were not mutually exclusive and that a severe ornamental style could have the same dynamic effect as a complicated floral design. There is a tendency to regard Eisenloeffel as an outsider in the art nouveau movement. However, his works reveal an extraordinary interest in the selection of appropriate materials; they also reveal the artist's admiration for surface—both characteristic features of art nouveau.

Eliel Saarinen's railway station in Helsinki (1904/1917) can be included among those cubic blocklike buildings that increasingly pointed toward the period beyond art nouveau. After 1905 and even more so after the First World War, architects and craftsmen turned directly to the people, renouncing the intermediary figure of the wealthy patron. Finnish art as represented by Saarinen was inspired by a direct feeling for nature that is characteristic of all Scandinavian peoples. The often magnificently remote Finnish

buildings and works of art sparsely decorated with plant motifs reveal their origin in the legendary world of the Kalavalla.

The elemental force of Scandinavian art, which gave new inspiration to the art of Europe, informs the paintings of the Norwegian artist Edvard Munch. Munch was the most talented and independent artist of the whole movement. His work is almost exclusively concerned with man—his anxieties, joys, and sorrows. While still a child, Munch lost his mother and sister, and the tragedy of his own life predisposed him toward a final surrender to the despairing mood of the fin de siècle. Munch studied academic painting in Paris, but he perceived the city as alien to him. His friendship with Samuel Bing and Julius Meier-Graefe brought him into contact with the artists of the art nouveau movement. Munch adopted various characteristics of art nouveau: the sweeping repetition of forms, the concept of parallel compositions, and the dark contours of his figures. However, he did not employ these stylistic techniques as mere ornamental elements but rather used them to express the essence of his representations, letting lines become the bearers of a mood. Munch also grew beyond the symbolists, whom he had met in Paris, for he psychologized his themes. Munch's relationship to women was ambivalent and he expressed this ambivalence in endless variations. For Munch, a woman was at once a Madonna and a vampire, the symbol of both innocence and sin incarnate. His art was motivated by a desire to analyze human emotions, and his works often represent a leap into a mystical dimension. A kiss, evening, melancholy, anxiety, adolescence, jealousy, the dance of life—all these themes exist on many levels. The closeness to nature that characterizes art nouveau is intensified in Munch's work; man and nature become entirely fused, both bound together in a single expressive network of lines. In *The Shriek,* originally painted in oil in 1893 and repeated in a lithograph (fig. 85), nature possesses a shattering power. The force of man's primal scream and of nature surges in waves across the whole painting. In 1889 Munch declared his artistic program and thereby took decisive leave of his formal allegiance to the decorative aspect of art nouveau: "One should no longer paint rooms inhabited by people who read and women who knit; one should paint living human beings who breathe and feel, who suffer and love."

Painting and Sculpture at the Turn of the Century and Their Relationship to Art Nouveau

The expanded application of the concept of art nouveau to painting and sculpture is somewhat problematic; the most important analyses have excluded painting altogether. Other writers are skeptical and tend to reject the idea of art nouveau painting. In the present study, painting and sculpture have been mentioned only in connection with particular groups and only if there was no stylistic ambiguity. On the other hand, the idea of a total work of art, which characterized art nouveau in general, is also dominant in the painting of the period. Moreover, a painting is an element of a room and adds to its decoration in much the same way as a carpet, wallpaper, or furniture. This decorative function is a traditional aspect of painting. Thus, the fact that a picture serves a decorative purpose by no means relegates it to the genre of arts and crafts.

In order to evaluate art nouveau painting properly, it is necessary to subdivide the period on the basis of characteristic stylistic elements. It is not sufficient to designate all the paintings produced between 1895 and 1910 as "art nouveau" and to evaluate them on the basis of stylistic features common to the whole period. Precise definitions for each subperiod are necessary, and yet this is a task that has been largely neglected in the past.

Like art nouveau painting, the sculpture of the period almost always appears in a "combined" form. Free form was not an ideal; instead, artists created reliefs, statuary for fountains, statuettes, and ornaments for buildings. In these works, form was as important as in arts and crafts. Much of the sculpture of the epoch was destroyed during the two world wars. To the extent that a work was not designed for the interior of a room or a building, it tended to be located in public places and was therefore exposed and vulnerable to the vicissitudes of history. Much remains only on paper. Thus

86 Jan Toorop, *The Three Brides*. 1893

one is forced to draw analogies to small-format sculptures which, with all due respect, really belong to the genre of arts and crafts rather than to that of sculpture. Distinguishing criteria have been almost completely obliterated; hence critics have tended to evaluate objects on the basis of their symbolic content. A work was either "modern" or "traditional." If it was considered to be modern, it could be "rescued" for art nouveau.

Another question to be asked is whether critics have limited their study of art nouveau painting by focusing only on those works that are pure expressions of the fin de siècle, works that "celebrate beauty in one last gush of euphoria but represent in fact ultrarefined formalistic tendencies rather than growth and regeneration" (Jost Hermand). The line was admittedly a predominant stylistic element of art nouveau painting. However, if one concentrates only upon such features as "nervous contours," "waving masses of hair,"

"liquid technique," and carefully balanced "wallpaper patterns," one must include a whole group of painters who consciously employed stylistic devices characteristic of art nouveau but did not do so exclusively and thus participated in parallel artistic developments. If we limit our analysis only to the masters of this style while excluding artists of secondary importance, the historical importance of the movement becomes even more questionable. One begins to wonder whether the critic could not do without the label "art nouveau" altogether, in view of the fact that a painter like Schmalenbach, who is considered the most representative example of art nouveau painting, can also be classified among the "masters of allegorical arts and crafts." In short, although art nouveau was unquestionably a decorative art form, it manifested itself principally in arts and crafts, and one must seek its best examples in that genre in order to give this movement the significance it deserves.

Pierre Puvis de Chavannes can be regarded as a precursor of art nouveau painting rather than as its representative. His work reflects a profound feeling both for nature and for the humanistic ideals that characterized the nineteenth century. Thus his creations are diametrically opposed to the process of dehumanization of man and nature that gained ascendancy in the arts by the turn of the century. The spiritual quality of this painter's monumental, somewhat flat figures, which are painted with constructive transparency, are typical of the French painting tradition. Gustave Moreau also belongs to this tradition. However, Moreau's figures do not hover in an atmosphere of mystical melancholy; rather, his work is endowed with another aspect of French sensibility, namely an eroticism that pervades his pictures. Moreau's paintings evoke a luxurious atmosphere and are filled with arcane symbolism. Their subtle psychological element can be traced directly back to the English Pre-Raphaelites—among them Dante Gabriel Rossetti, Edward Burne-Jones, and Madox Brown—whose art represented a protest against the Biedermeier style. The features characteristic of Moreau's work are also found in the work of Arnold Böcklin, whose paintings are independently decorative in the freedom of their compositions. Böcklin's pictures reflect the artist's profound respect for nature, a respect that led him to draw inspiration for his ideal figures from natural phenomena. All the painters mentioned

87 Georges Minne,
 Kneeling Youth
 (marble sculpture). 1898/1906

above subscribed to what can be termed "sentimental naturalism," an attitude that also shaped the work of such art nouveau painters as Max Klinger.

The nabis, a group of young painters from the Académie Julien who had joined together in a reaction against Impressionism, comprised a self-contained circle. Maurice Denis was the theoretician of the group. (The name "nabis," taken from a translation of the Hebrew word for "prophets" indicates their orientation.) The program of the nabis was antinaturalistic; it supported, instead, Christian symbolism. Denis was a strict Catholic who dealt primarily with religious themes in which the world appeared as a serene paradise. With regard to formal elements, the nabis show some similarities with such painters as Denis Paul Serusier, Pierre Bonnard, Edovard Vuillard, Paul Roussel, Paul Verkade, and Félix Vallotton as well as Paul Gauguin and Vincent van Gogh. They specifically adopted Gauguin's "syntheticism"—large-format flat figures painted in

brilliant colors. The lyrical aspect of their painting, expressed, for example, in gliding movement, derives from van Gogh. Odilon Redon and the Belgian painter Fernand Khnopff were close in style to the nabis. In their works, too, literary symbolism is manifested in its most pronounced form.

The German painter Paula Modersohn-Becker was also influenced by Gauguin and van Gogh. However, the elements of symbolism in her work possess greater clarity. Modersohn-Becker's figures are simple and reveal a profound love for the human being. While her romantic enthusiasm for nature places her within the circle of the sentimental naturalists, Modersohn-Becker had grown beyond them in a formal sense with her restrained, flat figures, the natural directness of which has nothing in common with art nouveau. Walter Leistikow's work and that of the others from the Dachau group reveals an intensely lyrical relationship to nature. Their artistic realism is a unique and independent element of the turn-of-the-century painting style. Traces of provincialism rooted in a local natural environment are found in works produced by members of Die Scholle, whose graphics conform completely to the precepts of art nouveau.

Ferdinand Hodler's paintings represent a borderline case. The parallelism of his groups of figures, which have a lathed and exaggeratedly flat appearance, shows the influence of art nouveau. On the other hand, these figures are frozen in a solemn monumentality. This can be explained by Hodler's desire to represent strength and nationalistic heroism, which made him a painter of the "expressive monument," so to speak.

The question of whether there was such a thing as art nouveau sculpture would merit a long discussion. Sculptors such as Auguste Rodin, Aristide Maillol, and Constantin Meunier do not fit in such a framework. Statuary remained largely traditional. Statuettes encompassing a variety of styles—from natural symbolism to luxuriant ornamentation—belong to the genre of arts and crafts, where they play an important and representative role. The Belgian sculptor Georges Minne, who was equally at home in the world of allegorical naturalism and sociocritical realism, was perhaps the only genuine art nouveau sculptor. His elongated, stylized figures, which generally take their direction from rhythmic calligraphic lines, justify this assessment (fig. 87).

Art Nouveau Glass:
One of the Most Remarkable Phenomena of the Movement

Guimard's remarkable and representative métro entrances, with which this study began, are paralleled by an equally unique phenomenon with which this investigation will conclude.

Among the most important works produced during the art nouveau period are its subtle, unique glass works. The best of these examples are beautiful enough to have satisfied the most rarefied tastes of the day. By and large lacking in symbolic content, these works radiate a morbid charm that has always tended to fascinate critics (fig. 7). In its glass art, art nouveau sent forth its most exquisite blossoms; unfortunately, it is also in this genre that we find the poorest-quality mass-produced imitations. Although glass art offered the most wonderful and fruitful possibilities, the genre also posed the greatest danger of cheap reproduction.

It is impossible to evaluate this contribution to the art of the turn of the century without examining the multiplicity of complex techniques that were available to art nouveau glass artists. Nineteenth-century historicism had led to the reconstruction of techniques for reproducing relief etching and intaglio on layered glass such as that seen on Chinese tobacco boxes. In addition, the nineteenth century saw the emergence of cameo glass, inlaid glass or marquetry, fluorescent glass, Favrile glass, and enameled glass. Art nouveau perfected each of these types.

The astonishing number of new and newly discovered possibilities for glass decoration allowed the "glass poets" of art nouveau to capture between the fragile walls of their vessels the tender beauty of a flower, the hazy light of a sunrise, or the shimmering colors of a peacock feather. The outlines of many of these vessels were ornaments in themselves. Stems were so thin that the bowls of

goblets appeared to float. Openings were shaped like unfolding petals; forms flowed into space. The elegance of these shapes, often reminiscent of delicate minarets, reveal the influence of Oriental glass, whose tangle of lines and meandering waves had a lasting effect on art nouveau (fig. 88).

French art nouveau glass is characterized by its extreme refinement and grace, which serve to interpret nature poetically and to arouse a whole spectrum of feelings in the viewer. Surprise, which contains an impressionistic element of charm, the suggestion of movement, the evocation of mood—all these things are responsible for the effect produced by this art, which also reflects the influence of Baudelaire's lyrics and the poetry of Victor Hugo and Stephane Mallarmé. The symbolic language of flowers, which was a common feature of late manneristic art as well as the art of the Middle Ages came to life once again during the romantic period. Art nouveau created its own flower mysticism. The *Fleurs du mal* comprised a negative form of mysticism, a bouquet of "stupidity, error, sin, crudeness, and vulgarity" (quote from Hofstätter, *Symbolismus*). In contrast, the lily was a flower of purity that conquered baseness. Withering blossoms bathed in diffuse light were a favorite motif. Pale blue or lilac contrasted with sickly pink, and watery green or lemon yellow mixed with pearl gray were favorite colors. The flamelike form of an exotic plant shoots up, brilliantly glazed and shimmering with irridescent light, in front of a dark background (fig. 89).

Emil Gallé perfected the floral form of glass art to the highest possible degree. For Gallé, flowers were not only beautiful forms of nature but also the bearers of poetic emotions. His botanical studies taught him about the great variety of plant forms and made his involvement in his creations all the more intense. His ideas, which veritably flowed into glass, lost their individual identity and owed their life to nature alone. Gallé was equally a symbolist and an art nouveau artist. His "talking glass" (fig. 89) lost its function as a receptacle for flowers; a vase became nothing less than the realization of a mood, a feeling. Gallé often imprinted lines of poetry or the words of a symbolist poet on his vases. Indeed, the work of such poets may be regarded as the foundation of his art. Gallé's exhibits were triumphs and his glass was so sought after that he was compelled to employ numerous assistants. As a result, the

150

value of a "signed Gallé" decreased, since such techniques as relief etching and intaglio as well as *marquetterie de verre* [inlaid glass] demanded a great deal of time and the highest degree of craftsmanship.

A short description of the techniques employed by art nouveau glass artists will help to indicate the complexity of the genre. Layered glass was particularly popular. A hollow glass body was dipped into colored glass and coated with a thin layer of the liquid material. When the glass was later blown, the colored layer appeared either on the outer or inner wall of the vessel. This procedure could be repeated several times. Sometimes special tools were used to produce the colored layer. These were usually glass bars which were dipped in the desired color and heated until they began to melt, at which point an appropriate quantity would be snipped off with a pair of scissors and distributed evenly over the surface of the glass body. If the glass was then blown, the colored layer appeared on the exterior of the vessel. The engraver created a decoration out of the many colored layers. His work with the tiny etching wheels was extremely painstaking and comparable to sketching with charcoal or a fine paintbrush. Landscapes, figures, blossoms, tendrils, and intricate ornamentation were created in this way. With delicate strokes, plants, butterflies, and whole scenes were drawn upon the outer layer and then etched into the glass, layer by layer, until the final many-colored artwork—in relief or intaglio—stood before the artist—a veritable miracle of glass-cutting technique. Chemical processes could also be used to etch glass. The *graveur à l'acide* first applied some appropriate base to coat the parts of the layered glass that were to retain their original color. The color on the uncovered portions was then etched away with corrosive material. Then different sections of the glass were coated and other parts left exposed. Through a repeated process of coating and exposure, portions of the original glass under all the layers came to shine through the colors according to a predetermined design. By using different corrosive materials and by varying the length of the etching process, it was possible to give the glass a polished, dull, or cracked finish, which often formed an integral

88 Louis Comfort Tiffany, Favrile glass. Ca. 1900 ▷
89 Emile Gallé, Decorative glass. Ca. 1900 ▷ ▷

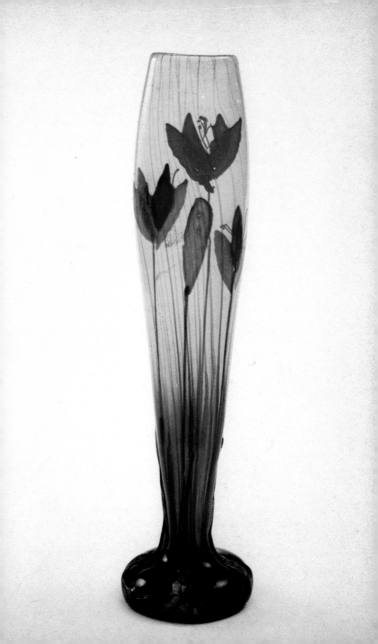

part of the decoration. Because the acid fumes were poisonous, the engravers customarily worked over a trough set up in open-air studios. When the last stage of the etching process was complete and the final decoration had emerged from the various layers, the *graveur à la roue* took over, using tiny copper wheels to produce the fine details.

Glass marquetry or inlaid glass, which perfectly symbolizes the overrefined charm, intense estheticism, and mystical irrationality of art nouveau (fig. 54) deserves our highest admiration. The technique necessary to produce these works required the highest degree of manual dexterity as well as the sure eye of an artist. In this process, which involves the combined use of hot and cold glass, the role of the *graveur* is taken over by the *verrier à chaud*. He first heats the glass and coats it with an opaque or transparent but colorless layer. As he is coating the glass with the new layer, he uses the molten material to shift a design into the proper position. When he is finished, the decoration is "captured" between two layers of glass. Among such designs used by art nouveau glass artists were algaelike shapes floating in droplets of water or branches of a tree bent down as if in a thunderstorm. Some parts of vases produced in this manner still required finishing with the etching wheel. Usually, this step was necessary in order to provide a connection between the exterior surface of the vessel and the inlaid decoration. The resulting glass objects create a three-dimensional effect—which was the ultimate goal of this extraordinarily complex technique. The viewer gazes directly into the middle of a landscape, reading it uninterruptedly rather than in a succession of superimposed layers. Glass marquetry was totally unique. The works created by this technique radiate an innate quality that transcends any particular stylistic movement (fig. 7).

The artists of the Nancy school were masters of glass art. Besides Gallé, Antonin Daum, who took over his father's glassworks in 1883, led art nouveau glass to its highest peaks. At the time, the Daum factory was producing only glassware for everyday use. Daum and his brother Auguste, however, adapted it to the production of art glass, calling it the Verrerie d'art de Nancy. Glass objects bearing the signature "Daum Nancy" rank among the best productions of the movement (fig. 54). Glass engraving was not, of course, invented by art nouveau artists; however, they developed

the technique to the highest levels. The oldest known glass with an etched design dates back to the fourth century B.C. This object, a bowl found near Ephesus, is decorated with a central floral motif. The luxurious glassware produced during the Roman Empire contained every known possibility for the decoration of glass. However, the highly developed art of cutting and polishing glass as practiced in Rome undoubtedly drew upon the 4,000-year-old tradition of stonecutting as it developed in the Near East. Most of the relief glass pieces from Rome and Alexandria have an opaque white coat, from which the reliefs were cut. The blown-glass base was usually dark blue. Favorite decorations were mythological scenes, which again became popular in the nineteenth century.

Since the Han dynasty (206 B.C.–A.D. 720), there were glass artists in China who, over the course of centuries, had developed the art of cutting glass to a very high level. The seventeenth century, however, was particularly rich in the production of glass art, and the variety of styles was astounding. Surveying the world, we see that there were various national tendencies. Chinese artists produced mainly glass reliefs, while India developed a charming miniature style adorned with gold decoration. In contrast, the rest of Asia produced glass that was characterized by its formal elegance and absence of decoration. In Venice, artists borrowed Renaissance forms and created stylized glass objects. Spanish glass was a hybrid and depended heavily on Venetian models. France produced plate glass, while the Netherlands was known for its diamond-point etched glass. England produced a type of leaded glass containing fluorite, while Bohemia experimented with chalk-based glass, which was less fragile. Potsdam was known for its golden ruby glass, while Nuremberg was famous for its etched glass and the Tyrol for etched and cold-painted glassware. Sweden, like Spain, was influenced by Venetian glass. German-speaking countries produced enamel tankards. Denmark was known for Waldglas (forest glass). Russia already had its first glass studios near Washrassenk and Moscow and even America produced its own glass. This brief review of the history of art glass shows how many possibilities were

90 Louis Comfort Tiffany, Round vase. Ca. 1900 ▷

91 Louis Comfort Tiffany, Lamp. Ca. 1900 ▷ ▷

155

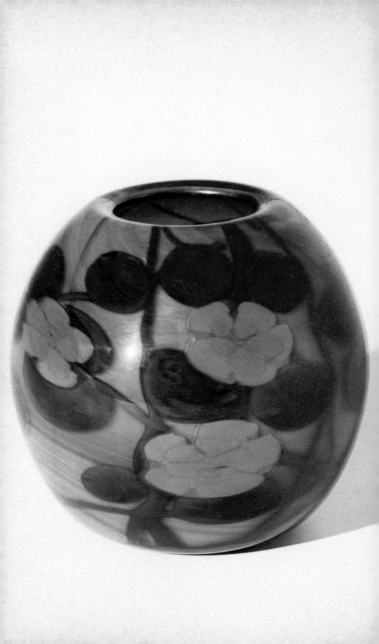

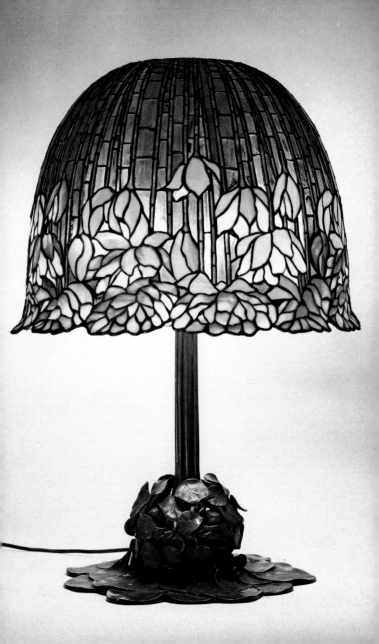

available even centuries ago. It also shows the degree to which this exclusive material spurred the artistic imagination to flights of fancy.

The nineteenth century produced glass in every conceivable style. Individual pieces of hand-painted glass yielded to plain colored glass and even pottery, which could satisfy the constantly increasing demand. Mass production caused the old traditions and techniques of handcrafted glass to sink into obscurity and a confusing mass of new styles to flood the glass industry. Then, from England, came the call for a renewal of arts and crafts and thus also for a renewal of glass art. In 1859, William Morris commissioned the architect Philip Webb to design glass for his Morris Company, but Webb's glass, too austere and puritanical, found little favor. In contrast, the official classical trend was very popular. On the occasion of the World's Fair of 1851, the glass manufacturer Benjamin Richardson offered a prize of £1000 to the artist who could reproduce most perfectly the celebrated Roman relief amphora known as the Portland Vase. The prize was won by John Northwood, who was already known because of his Elgin Vase, a 40-cm. tall glass vessel in the Greek style decorated with a group of riders modeled after the frieze of the Parthenon.

Numerous glass artists on the continent followed Northwood's example. The so-called cameo glasses were precursors of the etched vases of the Nancy school.

As the nineteenth century drew to a close, there was increasing dissatisfaction with the mass-produced glassware drenched in historicism. Art nouveau required the production of individual, hand-crafted objects. Neither practical considerations nor cost was important. The new techniques had only one purpose: the realization of an "ideal glass" and the approximation of "ideal decoration." The *Gesamtkunstwerk,* which represented a union of all the arts, found a parallel in the romantic conceptions of floral art nouveau and, in its concord with nature, glass art evolved a new kind of universality. The finest examples of art nouveau glass produced around 1900 are comparable in quality to the best examples of the past. Admittedly, Gallé's work can be seen as an exaggeration of the free play of the imagination. A certain mannerism can also be detected in art nouveau glass. However, although one may prefer the old and timeless forms of everyday

utensils, it is impossible to ignore the artistic snob appeal that captivates and enthralls the observer of a *verre parlant* even today.

Like Gallé in France, Louis Comfort Tiffany in America created a new form of glass art and led art nouveau to another high point (fig. 90). Tiffany was one of those rare universal artists who are masters of every genre but finally choose a single medium through which to express their genius. Rather than entering the workshop of his father's famous jewelry firm, Tiffany, upon completing his studies as a painter, turned to interior decoration. The influence of Japanese art is evident in his flat wall treatments, which were blended with Oriental designs, and his interest in classical antiquity pointed the way to his superb creations in glass. One of Tiffany's first successes was the perfection of a technique for producing opalescent glass surfaces such as those seen in the glass of the Roman Empire. Admittedly, it is uncertain that the classical glass vessels originally possessed the irridescent quality of Tiffany glass or that this luminescence was not, rather, a result of erosion. In any event, Tiffany recognized the charm of the luster effect as early as 1873 and sought to produce this metallic quality by means of a chemical process.

Tiffany patented "opalescent glass" and first used it for windows and in glass paintings. Opalescent glass—produced by allowing different colored glasses to flow together into abstract, irregular striations resembling ornamental marble (fig. 7)—lent itself well to glazing.

Tiffany's creations are essentially layered glass. Starting with opalescent glass as a base, various layers of colored glass were laid one on top of the other. The luster effect was then achieved through the use of chemicals.

After 1893, Tiffany made almost exclusive use of the technique whereby the celebrated Favrile glass was made. Favrile is a kind of luster glass with a quality—often seen in glass painting—reminiscent of inlay or mosaic. Thin layers of metal powder are used to create the luster effect. A powder of precious metals can be used, and the technique can be varied depending on whether a dull or shimmering finish is desired. Tiffany's glassware is often decorated with fine dark threads drawn from plate glass. "Combed" glass is the name given to objects whose decoration is achieved through an admixture of aluminum oxide produced from dissolved sandstone

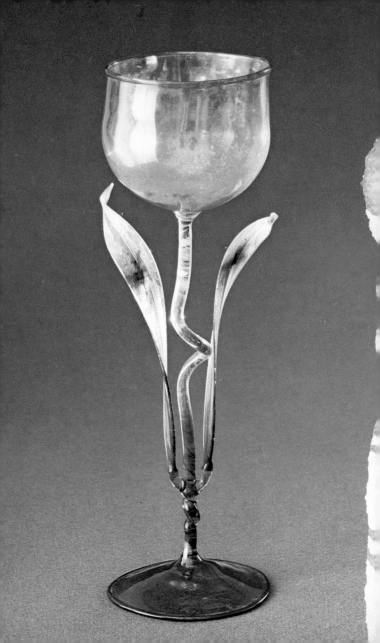

particles. Luster effects are gradually produced by allowing oxide mists to form on the outside surfaces of the glass. Decoration produced by this method of oxide precipitation is anything but naturalistic in effect; the glass vessels resemble linear ornaments. And yet these objects are natural forms after all. Their shapes are like exotic flowers whose dynamic movements are actually paralleled by their linear decoration. Delicate stems support the most graceful blossoms, which appear to be frozen in random motion. The feeling of spontaneity and random movement was raised into an esthetic principle by Tiffany, so that the ultimate shape of a glass was actually determined during the process of its fabrication. Light, color, and motion merge freely together in these flowers of fantasy. In describing these works, it is difficult to avoid terminology borrowed from nature. Thus critics have compared combed glass to peacock feathers and Favrile glass to a butterfly's wing, a pearl, a seashell, or a soap bubble. Tiffany's early glass objects were markedly influenced by classical forms. Bases, stems, and bowls were clearly demarcated. Persian perfume bottles, antique vessel shapes, and Roman double-gourd flasks provided models. However, Tiffany soon liberated himself from these; more precisely, they were gradually transformed under his hands into new, independent forms. Outlines became fluid and merged with the decoration. The result was the creation of dynamic, asymmetrical designs that had no purpose but to give esthetic delight. These unreal, delicate, luxurious works call to mind the treasures of the *Thousand and One Nights.* Tiffany's imagination was boundless when it came to the discovery of new forms. His infinite inventiveness sometimes led him to design works that were exotic to the point of being bizarre. However, the delicacy with which their surfaces were treated prevented these glass objects from creating a jarring effect. Tiffany's success was enormous and, like his opposite, Gallé, he was forced to abdicate control over both design and production. The increasingly depersonalized studio fabrication of Tiffany's designs led to a considerable decline in quality. Tiffany lamps were particularly popular. These works were produced by the same techniques that were used to fabricate other types of glass objects; however, they have a stronger Oriental

92 Karl Keopping, Ornamental glass. Ca. 1900

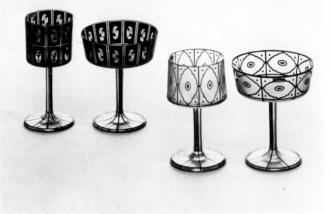

93 Josef Hoffmann, Four ornamental glasses, Ca. 1905

flavor. Their brilliantly colored shades spread out like umbrellas over sculpted bronze bases. These lamps produce a muted, mysterious light that symbolizes the essence of art nouveau (fig. 91).

Tiffany's glass influenced all of Europe. Luster glass was produced mainly in Austria, where American techniques were varied and in some cases even perfected. The most important of the glass studios was the Bohemian firm of Lötz Witwe. Lötz glass was characterized by the contemporary need for freedom from traditional form. The artists who worked there also had a singular knowledge of the chemical and physical properties of glass, and this redounded to the excellence of the products. Experiments with light refraction as well as the use of copper, iron, and precious-metal sulfates for the creation of luster colors led to the production of objects whose beauty was comparable to that of Tiffany glass. The extraordinarily thin "papillon glass" became the trademark of the Lötz studio. The surfaces of this irridescent glass shimmer with the colors of a rainbow—the effect produced by exposing the molten glass to a variety of oxide mists (fig. 74).

Ferdinand von Poschinger's studio in Buchenau produced glass decorated with peacock feathers that was notable for its delicate colors. Josef Pallme-König of Steinschónau experimented mainly with techniques for producing combed glass as well as with methods for applying the glass threads that crisscrossed his dark vessels like delicate nets (fig. 7).

There were many other glassworks in which artists experimented with the techniques used by Gallé and Tiffany. However, no decisive innovations resulted and the glass—of varying quality— produced in these establishments conformed to what had become fashionable.

In Berlin, Karl Koepping (fig. 92) and Josef Zitzmann created ultrarefined, luxurious glassware without, however, adding to the technical sophistication that had already evolved. The charm of these products lay in their extraordinary fragility and nervous linearity, which was a basic feature of art nouveau in general. Glasses were often created in the form of a flower; transparently thin bowls hovered above gently curved stems framed by narrow curling leaves. In addition to these purely decorative objects, Koepping also designed everyday glassware whose simple forms are still valid today.

The Ehrenfeld glassworks near Cologne also produced glass for everyday use. Peter Behrens, among others, created designs for this firm. These colorless glasses were sparingly decorated, yet their formal exaggeration makes them genuine art nouveau products. Another architect, Josef Hoffmann, also produced glass designs that derived from the geometrical variant of art nouveau. Hoffmann's simple cylindrical vessels (fig. 93) are subdivided into geometrical areas in which delicate, small-format designs are placed.

> We see here a pure ornamental style characterized by precise regularity and order, symmetrical decoration which could be infinitely expanded. To some extent, the motifs have been borrowed from nature. However, the vegetable elements are no longer in motion and do not possess independent life. Rather, they have become mere drawings." (Hann's-Ulrich Haedeke, Hoffmann's designs were in Bauch/Selig [ed], *Jugendstil . . .*) commissioned by the firm of J. L. Lobmeyer, which had always remained aloof from the general developments of the period. Like Tiffany and others, Hoffmann's designs were executed in layered glass, usually black.

France, America, Austria, and Germany were the centers of art nouveau glass art. French glass captivated the viewer with its floral symbolism. In the hands of such artists as Dammouse and Décorchement, this genre became a hybrid, occupying a position somewhere between glass and ceramics. Both men created the thinnest and most delicate vessels out of glass paste, a glass mixture that is baked in a kiln like clay pottery (fig. 18). Austria, in keeping with its traditions, was open to all possibilities. America was represented by Favrile glass. Germany was noted for its efforts to combine art and functionality. This brief survey of art nouveau glass can obviously do no more than scratch the surface. It should be noted in conclusion that glass art was one of the least complicated forms of art nouveau. Nevertheless, it was in this genre that the estheticism of the age found its optimal expression.

Conclusion

Art nouveau crossed the threshold into the twentieth century. If we follow its development and progress in chronological sequence, it is possible to understand the sum and substance of the movement. Its point of departure, its roots, lay in the nineteenth century. Leaping forward from this fixed point in time, artists suddenly landed in a new era without having touched the earth. Art nouveau artists had the strength and determination to oppose historicism and the bastardization of styles that resulted from imitation, to turn away from tradition, and to blaze new trails. However, they did not have the power to carry a new form of art on their shoulders. Their forward leap was incomplete; it remained merely a gesture. The art nouveau movement reflects a very particular state of affairs, both in a historical and a formal sense. Dynamism, vibration, oscillation—these were the modes through which it found expression. By 1905, however, its violent pulse began to slow as ecstasy yielded to reflection and more sober ideas. Art nouveau forms were manifold; their dynamism and vitality call to mind the metamorphoses of living organisms. Yet we see no unbroken figures, no forms created in one mold; art nouveau images are made up of a provocative montage of baroque and abstract elements. If one part is left out, the whole form collapses; if one part is too large, the construction becomes topheavy.

In this study, we have attempted to present art nouveau as a coherent but limited epoch, a movement that produced works of sufficient quality to compare favorably with works of the future as well as those of the past. We have also attempted to present the problematic aspects of art nouveau and to put its contradictions into perspective. The influence exercised by this transitional period should not be ignored. But it is hardly justified to evaluate art nouveau only by examining its contribution to the "modern" age and to "modern" art. This extraordinarily fertile movement at the turn of the century was a law unto itself. For a certain period of time, the art nouveau style swept up all branches of artistic activity. It does not matter that its exponents interpreted it in different ways or that its successors left its vision behind.

The Most Important
Art Nouveau Architects
and Their Principal Works

Peter Behrens (1868–1940)

Darmstadt	
(Mathildenhöhe):	His Own House 1901
Hagen:	Klein House 1906–1907
	Schröder House 1908–1909
Berlin:	Turbine Factory of the AEG [General Electric Company] 1909

Hendrik Petrus Berlage (1856–1934)

Bussum:	His Own House 1893
Amsterdam:	Stock Exchange 1898–1903

Daniel H. Burnham (1846–1912; assistant, C. B. Atwood)

Chicago:	The Rookery 1886
	Monadnock Building (northern section) 1889–1891
	Reliance Building 1894

August Endell (1871–1925)

Munich:	Elvira Photographic Studio 1896–1897
Insel Föhr:	Sanatorium 1901
Berlin:	Buntes Theater 1901

Antonio Gaudí (1852–1926)

Barcelona:	Casa Vicens 1878–1880
	Palacio Güell 1885–1888
	Colegio de Santa Teresa de Jesus 1889–1894
	Sagrada Familia 1884–1926
	Santa Coloma de Cervello 1898–1914

 Casa Battló 1905-1907
 Casa Milá 1905–1907
 Parque Güell 1905
 Casa Calvet 1898–1901
 Bellesguard 1900–1902

Hector Guimard (1867–1942)
 Paris: Le Castel Béranger 1894–1897
 Villa Flore 1898
 Ecole Humbert de Romans, completed 1902
 Métro Station 1899–1900
 Hôtel Nozal 1901
 House on Rue la Fontaine, completed 1921
 Sceaux: Le Châlet Blanc 1901

Josef Hoffmann (1870–1956)
 Vienna: Furnishings of the Apollo Firm 1900
 Residential Suburb on the Hohen Warte
 1902–1903
 Furnishings of the Vienna Workshop 1903
 Purkersdorf Sanatorium 1904–1905
 Fledermaus Cabaret 1907
 Ast House 1910–1911
 Hohenberg: Church 1903
 Kladno: Poldihütte Trade Union Hotel 1904
 Brussels: Palais Stoclet 1905–1911

Victor Horta (1861–1947)
 Brussels: Tassel House 1892–1893
 M. Frisun House 1893–1894
 van Eetvelde House 1895–1896
 Grand Bazar Anspach 1895
 Maison Rue Americaine 22 and 23 1896
 Palais Solvay 1895–1900
 Maison du Peuple 1896–1899
 Horta Museum 1898
 Hôtel Aubecq 1900
 A L'Innovation 1901
 Gros Wancquez 1903–1905

Charles Rennie Mackintosh (1868–1928)
Glasgow: Argyle Street, Tearoom 1897
 Ingram Street, Tearoom 1901
 Willow Tearoom 1903–1906
 Glasgow School of Art 1897–1899
 Mackintosh House on Main Street 1900
Vienna: Interior decoration of the house of a patron
 1901
 Music room for Fritz Wärndorfer 1901
Kilmacholm: Windy Hill 1899–1901
Helensburg: Hill House 1902–1903

Joseph Maria Olbrich (1867–1908)
Vienna: Vienna Secession House 1897–1898
Darmstadt
(Mathildenhöhe): Studio Building (unexecuted design) 1899
 Building for Two-Dimensional Art 1900
 Playhouse for the Princess 1902
 His own house 1901
 The Wedding Tower 1901–1908

Richard Riemerschmid (1868–1957)
Munich: Theater 1900–1901
 His own house 1901

Louis Sullivan (1856–1924)
Chicago: Old Stock Exchange 1894
 Auditorium Building 1887–1889
 Walker Department Store 1888–1889
 Northern Section of the Gage Group
 1898–1899
 Carson, Pirie, Scott & Co. Store 1899–
 1904
Buffalo Guaranty Building 1895

Henry van de Velde (1863–1957)
Uccle: Bloemenwerf House 1895–1896
Berlin: Furnishings for Count Harry Kessler 1898
 Furnishings for the Habana Company
 1899

168

	Haby Beauty Salon 1901
Paris:	Study for Julius Meier-Graefe 1898
Chemnitz:	Esche House 1902
Hagen:	Karl-Ernst-Osthaus Museum (formerly the Folkwang Museum) opened in 1902
	Hohenhof House 1908
Wetter:	Schede House 1904
Ausberg:	Deutsche Bank 1903
Weimar:	School of Applied Art and School of Art 1904/1908/1911
	Pappeln House 1906

Otto Wagner (1841–1918)

Vienna:	Nussdorfer Nadelwehr 1897
	Karsplatz Train Station 1897
	Majolika House 1898
	City Savings Bank 1906
Steinhof:	Domed Church 1906

Bibliography

Ahlers-Hestermann, Friedrich. *Stilwende. Aufbruch der Jugend um 1900*. Berlin, 1941 (2nd. ed., Berlin, 1956).

Amaya, Mario. *Art Nouveau*. London: Studio Vista, 1966.

Ashbee, Charles. *A Short History of the Guild and School of Handicraft*. London, 1890, I, pp. 19–31.

Bahr, Hermann. *Sezession*. Vienna, 1900.

Bajot, Edouard. *L'Art Nouveau—Décoration et Ameublement*. Paris, 1898.

Bauch, Kurt, and Seling, Helmut, eds. *Jugendstil. Der Weg ins 20. Jahrhundert*. Munich, 1959.

Bayard, Emile. *Le style moderne. L'art reconnaître les styles*. Paris, 1919.

Behrendt, Walter. *Der Kampf um den Stil in Kunstgewerbe und Architektur*. Berlin, 1920.

Benesch, Otto. *Edvard Munch*. London and Cologne, 1960.

Berlage, Hendrik Petrus. *Gedanken über den Stil in der Baukunst*. Leipzig, 1905.

Blount, Berniece and Henry. *French Cameo Glass*. Des Moines, 1967.

Bott, Gerhard. *Jugendstil in Darmstadt um 1900*. Darmstadt, 1962.

Bott, Gerhard, and Bergsträsser, Gisela. *Plakate um 1900*. Darmstadt, 1962.

Braun, Heinz. *Jugendstil—Art Nouveau—Modern Style*. Supplement of the Institute for Film and Illustration in Teaching and Learning. Munich, 1971.

Buchert, Josephe. *Fleurs de Fantaisie*. Paris, n.d.

Champigneulle, Bernard. *Art Nouveau.* Translated by Benita Eisler. Woodbury, N.Y.: Barron's, 1976.

Chavance, Richard. *L'Art Français depuis vingt ans. La céramique et la verrerie.* Paris, 1928.

Collins, George R. *Antonio Gaudí.* New York: G. Braziller, 1960.

Cook, Theodore A. *The Curves of Life.* New York, 1914.

Crane, Walter. *Line and Form.* London, 1900.

Cremona, Italo. *Die Zelt des Jugendstils.* Munich and Vienna, 1966.

Endell, August. "Die Möglichkeiten und Ziele einer neuen Architektur." In *Kunst und Dekoration.* Darmstadt, 1897–98, I, pp. 141–153.

_____. "Vom Sehen." In *Die Neue Gesellschaft* I, Berlin, 1905.

Fierens, Paul. *La tristesse contemporaine.* Paris, 1924.

Fontainas, André. *Mes souvenirs du Symbolisme.* Paris, 1924.

Fraipont, G. *La fleur et ses applications décoratives.* Paris, n.d.

Fuller, Loie. *Quinze Ans de ma vie.* Paris, 1908.

Gallé, Emile. *Ecrits pour l'Art—1884/89.* Paris, 1908.

Gillon, Edmund Vincent. *Art Nouveau. An Anthology of Design and Illustration.* New York: Dover, 1969.

Grasset, Eugène. *La plante et ses applications ornamentales.* Paris, 1899.

Graul, Richard. *Die Krisis im Kunstgewerbe.* Leipzig, 1901.

Grover, Ray and Lee. *Carved and Decorated European Art Glass.* Rutland, Vermont: Tuttle, 1970.

Guerrand, Roger H. *L'Art Nouveau en Europe.* Paris, 1967.

Guimard, Hector. "An Architect's Opinion of Art Nouveau." In *The Architectural Record.* London, p. 190.

Hermand, Jost. *Jugendstil. Forschungsbericht 1918–1964.* Stuttgart, 1965.

Hoeber, Fritz. *Peter Behrens.* Munich, 1913.

Hoffmann, Josef. *Einfache Möbel. Das Interieur.* Vienna, 1901, II, pp. 193–208.

Hofstätter, Has. H. *Symbolismus und die Kunst der Jahrhundertwende.* Cologne, 1965 (2nd. ed., Cologne, 1973).

_____. *Geschicte der europäischen Jugendstilmalerei.* Cologne, 1963 (4th ed., Cologne, 1972).

_____. *Aubrey Beardsley.* Woodbury, 1979.

Howard, Thomas. *Charles Rennie Mackintosh and the Modern Movement.* London: Routledge & K. Paul, 1952.

Johnson, Diane. *American Art Nouveau*. New York: H. N. Abrams, 1979.

Jones, Owen. *Grammar of Ornament*. London, 1856. Reprint. New York: Van Nostrand Reinhold, 1972.

Jullian, Philippe. *Dreamers of Decadence. Symbolist Painters of the 1890s*. New York: Praeger, 1971.

Juyot, Paul. *Louis Majorelle, Artiste Décorateur, Maître ébéniste*. Nancy, 1926.

Kempton, Richard. *Art Nouveau: An Annotated Bibliography*. Los Angeles: Hennessey & Ingalls, 1977.

Kleiner, Leopold. *Josef Hoffmann*. Berlin, 1927.

Kock, Robert. *Louis C. Tiffany. Rebel in Glass*. New York: Crown Publishers 1964.

Lenning, Henry. F. *The Art Nouveau*. The Hague: M. Nijhoff, 1951.

Luthmer, F. *Blüthenformen als Motive für Flächenornament*. Berlin, 1893.

Mackintosh, Alastair. *Symbolism and Art Nouveau*. Woodbury, N.Y.: Barron's, 1978.

Madsen, Stephan Tschudi. *Art Nouveau*. Translated by R. I. Christopherson. New York: McGraw-Hill, 1967.

_____. *Sources of Art Nouveau*. Translated by R. I. Christopherson. New York: G. Wittenborn, 1956.

Mass, Henry; Duncan, J. L.; and Good, W. G., eds. *The Letters of Aubrey Beardsley*. Rutherford, 1970, p. 32.

Meier-Graefe, Julius. *Die Weltausstellung in Paris 1900*. Berlin, 1907.

Mrazek, Wilhelm. *Die Wiener Werkstätte. Modernes Kunsthandwerk von 1903–1932. Österreichisches Kunstgewerbemuseum*. Vienna, 1967.

Obrist, Hermann. "Luxuskunst oder Volkskunst." In *Dekorative Kunst*. Munich, n.d.

_____. *Zweckmässig oder Phantasievoll*. Munich, 1901.

Pehnt, Wolfgang. *Die Architektur des Expressionismus*. Stuttgart: Verlag Gerd: Hatje, 1973.

Pevsner, Nikolaus. *Pioneers of the Modern Movement from William Morris to Walter Gropius*. London, 1936.

_____. *Pioneers of Modern Design from William Morris to Walter Gropius*. New York: Museum of Modern Art, 1949.

————. *Charles Rennie Mackintosh*. Milan, 1950.

————. *The Sources of Modern Architecture and Design*. New York: Praeger, 1973.

Pevsner, Nikolaus, and Richards, J. M., eds. *The Anti-rationalists*. London: Architectural Press, 1973.

Polak, Ada. *Modern Glass*. London: Faber & Faber, 1962.

Rheims, Maurice. *L'Objet 1900. Arts et Métiers Graphiques*. Paris, 1964.

Rickards, Maurice. *Posters at the Turn of the Century*. London: Evelyn, Adams, & Mackay, 1968.

Ridder, André de. *Georges Minne*. Antwerp, 1947.

Schmutzler, Robert. *Art Nouveau*. Translated by Edouard Roditi. New York: H. N. Abrams, 1962.

Selz, Peter Howard, and Constantine, Mildred. *Art Nouveau: Art and Design at the Turn of the Century*. New York: Museum of Modern Art, 1975.

Sembach, Klaus-Jürgen. *Betrachtungen über die Person Henry van de Veldes*. Munich, 1975.

Sternberger, Dolf. *Über den Jugendstil und andere Essays*. Hamburg, 1956.

Sterner, Gabriele. *Antoní Gaudí: Architecture in Barcelona*. Translated by Roger Marcinik. Woodbury, N.Y.: Barron's, 1982.

Symons, Arthur. *Aubrey Beardsley*. London, 1905, p. 40.

Taylor, John Russell. *The Art Nouveau Book in Britain*. London: Methuen, 1967.

Tiffany, Louis C. "Emile Gallé and the Decorative Artists of Nancy." In *The Studio*. London, 1903.

Velde, Henry van de. *Geschichte meines Lebens*. Edited by Hans Curjel. Munich, 1962.

————. *Zum neuen Stil* (selection from the writings of Henry van de Velde). Munich, 1955.

Verneuil, M. P. *L'Animal dans la Décoration*. Paris, 1898.

Vogue, Emile de. *Remarques sur L'Exposition de 1889*. Paris, 1889.

Waddell, Roberta, ed. *The Art Nouveau Style in Jewelry, Metalwork, Glass, Ceramics, Textiles, Architecture, and Furniture*. New York: Dover, 1977.

Wagner, Otto. *Moderne Architektur*. Vienna, 1895.

List of Illustrations

1 Hector Guimard: Métro station "Place du Palais-Royal." 1899–1900, Paris. *Photo:* Roger Viollet, Paris (invt. no. ND 5303)

2 Hector Guimard: "Lampes tulipes" of a Métro station. 1899–1900, Paris. *Photo:* Roger Viollet, Paris (invt. no. RV 201781)

3 Hector Guimard: Ramp of a Métro station. 1899–1900, Paris. *Photo:* Roger Viollet, Paris (invt. no. RV 197543)

4 Joseph Paxton: Crystal Palace. London Exposition. 1851. *Photo:* Deutsches Museum, Munich

5 Gustave Eiffel: Eiffel Tower. 1884–1889, Paris. *Photo:* Chevojon, Paris

6 Hector Guimard: Métro station "Hôtel de Ville." 1899–1900, Paris. *Photo:* Roger Viollet, Paris (invt. no. RV 202339)

7 GLASS *(from top left to bottom right):*
Louis Comfort Tiffany: Favrile glass. Ca. 1897, 4" (10.1 cm), personal collection of Knut Günther, Frankfurt/Paris/London
Ernest Leveillé: Vase. Ca. 1897, 8¼" (21 cm), private collection, Munich
Koloman Moser: Decorative glass. Ca. 1903, 6½" (16.5 cm), private collection, Starnberg
Emile Gallé: Bowl, Ca. 1885, 5¾" (14.5 cm), private collection, Starnberg
Louis Comfort Tiffany: Favrile glass. Ca. 1900, 17½" (44.5 cm), private collection, Starnberg
Louis Comfort Tiffany: Favrile glass. Ca. 1896, 7⅛" (18 cm), private collection, Starnberg
Antonin Daum: Layered glass. Ca. 1895, 11⅜" (29 cm), private collection, Munich
Louis Comfort Tiffany: Favrile glass. Ca. 1900, 14⅞" (37.7 cm), private collection, Starnberg
Josef Pallme-König: Glass vase. Ca. 1900, 11⅝" (29.5 cm), private collection, Munich
Photo: Sophie-Renate Gnamm, Munich (color plate)

8 Jules Lavirotte: Ceramic Hotel. 1904, Paris. *Photo:* Roger Viollet, Paris (invt. no. RV 875115)

9 Georges Hoentschel: Armchair. Ca. 1900, Musée des Arts Décoratifs, Paris (invt. no. 9405, cl. 2613)

10 Eugène Gaillard: Sofa. Ca. 1900, Musée des Arts Décoratifs, Paris (invt. no. 18302, cl. 3514)

11 Alphonse Mucha: Stool. Ca. 1900, Musée des Arts Décoratifs, Paris (invt. no. 32476 B, cl. 6338)

12 Alexandre Charpentier: Music stand. Ca. 1900, Musée des Arts Décoratifs, Paris (invt. no. 13064, cl. 5004)

13 Louis Majorelle: Piano. Ca. 1900, Musée des Arts Décoratifs, Paris (invt. no 21522, cl. 5888)

14 Louis Majorelle: Staircase. Ca. 1901, Musée des Arts Décoratifs, Paris (invt. no. 11318, cl. 3520)

15 Emile Gallé: Dragonfly table. Ca. 1900, height 29½" (75 cm), diameter of tabletop 29½" (75 cm), private collection of Joachim Telkamp, Munich. *Photo:* Sophie-Renate Gnamm, Munich

16 Emile Gallé, Tabletop (detail; cf. fig. 15). Ca. 1900, private collection of Joachim Telkamp, Munich. *Photo:* Sophie-Renate Gnamm, Munich

17 Emile Gallé, Buffet. Ca. 1900, Musée des Arts Décoratifs, Paris (invt. no. 41819, cl. 7353)

18 PORCELAIN AND GLASS *(from top left to bottom right):*
Emile Gallé: Layered glass. Ca. 1895, 5⅛" (13 cm), private collection, Munich
Juriaan Kok: Cocoa cup and saucer. 1901, 2⅞" (7.4 cm), private collection, Munich
Juriaan Kok: Cup and saucer, 1901, 2" (5 cm), private collection, Munich
Charles Robert Ashbee: Silver goblet. 1902, dia. 4⅛" (10.5 cm), (cf. fig. 52), private collection, Munich
Juriaan Kok: Vase. 1900, 5¾ (14.5 cm), private collection, Munich
Camille Naudot & Cie.: Drinking glass. 1894, 3½" (8.7 cm), private collection, Munich
Albert Dammouse: Small bowl. Ca. 1900, 2" (5 cm), private collection, Munich
Fernand Thesmar: Small bowl. 1903, 2" (5 cm), private collection, Munich
François Décorchemont: Small bowl. Ca. 1905, 2" (5 cm), private collection, Munich
Albert Dammouse: Footed bowl. Ca. 1900, 2⅛" (5.5 cm), private collection, Munich
Albert Dammouse: Bowl. Ca. 1900, 2⅜" (6 cm), private collection, Munich
Antonin Daum: Ornamental glass. Ca. 1905, 9⅞" (25 cm), private collection, Munich
Juriaan Kok: Vase, 1913, 8½" (21.5 cm), private collection, Munich
Juriaan Kok: Vase, 1909, 10⅞" (27.7 cm), private collection, Munich
Juriaan Kok: Vase, 1900, 8⅝" (22 cm), private collection, Munich
François Décorchemont: Drinking goblet. Ca. 1905, 8¼" (21 cm), private collection, Munich.
Photo: Sophie-Renate Gnamm, Munich (color plate)

19 Eugène Rousseau: Vase. Ca. 1900, 6¼" (17.2 cm), private collection, Starnberg. *Photo:* Sophie-Renate Gnamm, Munich

20 René Lalique: Diadem. Ca. 1900, Musée des Arts Décoratifs, Paris (invt. no. 34374, cl. 4591)

21 Alphonse Mucha: Brooch. Ca. 1895, 2¼″ × 1⅝″ (5.7 × 4 cm), Hessisches Landesmuseum, Darmstadt. *Photo:* Joachim Blauel, Gauting bei Munich (color plate)

22 Eugène Grasset: Comb. Ca. 1900, 6¼″ × 2¾″ (16 × 7 cm), Musée Galliera, Paris. *Photo:* Joachim Blauel, Gauting bei Munich (color plate)

23 Eugène Grasset: *Jeune femme dans un jardin.* Ca. 1900, Musée des Arts Décoratifs, Paris (invt. no. 38192, cl. 7554)

24 Henry Vever: Pendant. 1900, Musée des Arts Décoratifs, Paris (invt. no. 24532 B, cl. 4582)

25 Bourgeois: Wallpaper designs. 1901, Musée des Arts Décoratifs, Paris (invt. no. lib., cl. 6151 ABC)

26 CERAMICS *(from top left to bottom right):*
Ruskin pottery: Vase with lid. 1911, 7⅞″ (20 cm), private collection, Munich
Paul Jeanneney: Vase. Ca. 1900, 6¼″ (16 cm), private collection, Munich
Albert Dammouse: Vase. Ca. 1895, 8¼″ (21 cm), private collection, Munich
Edmond Lachenal and Emile Decoeur: Vase. 1901, 8¼″ (21 cm), private collection, Munich
Auguste Delaherche: Vase. Before 1904, 6¼″ (16 cm), private collection, Munich
Bernhard Moore: Vase. Ca. 1910, 4¼″ (10.9 cm), private collection, Munich
Christian Valdemar Engelhard: Vase with lid. 1895, 6¾″ (17 cm), private collection, Munich
Auguste Delaherche: Vase. Before 1894, 9⅞″ (25 cm), private collection, Munich
Jean Carriès: Vase. Ca. 1890, 7⅞″ (20 cm), private collection, Munich
Emile Gallé: Vase. Ca. 1885, 9½″ (24 cm), private collection, Munich
Edmond Lachenal: Vase. Ca. 1900, 9″ (23 cm), private collection, Munich
Photo: Sophie-Renate Gnamm, Munich (color plate)

27 Henry Jolly: Book binding. Leather and silver. Ca. 1900, 16¾″ × 10⅝″ (42.5 × 27 cm), Musée des Arts Décoratifs, Paris (invt. no. 9654, cl. 6331 A)

28 Georges de Feure: Vases. Ca. 1900, ca. 7⅞″ (20 cm), Musée des Art Décoratifs, Paris (invt. no. 12240, cl. 6375 AB)

29 Georges de Feure: Chocolate pot. Ca. 1900, ca. 9⅞″ (25 cm), Musée des Arts Décoratifs, Paris (invt. no. 15226, cl. 5865)

30 Raoul Larche: "Loie Fuller" lamp. Ca. 1900, 18⅛″ (46 cm), private collection, Starnberg. *Photo:* Sophie-Renate Gnamm, Munich

31 William H. Bradley: *The Serpentine Dance.* Lithograph. 1894, 20″ × 14″ (51 × 35.5 cm). *Photo:* Bildarchiv Foto Marburg (invt. no. Z 11345)

32 Anonymous: Shop window in Douai. Ca. 1900. *Photo:* Roger Viollet, Paris (invt. no. RV 820704)

33 Hector Guimard: Entrance to the Castel Béranger apartment house. 1894–1897, Paris. *Photo:* Rogert Viollet, Paris (invt. no. RV 875062)

34 Hector Guimard: Detail of a chair. Ca. 1900. Musée des Arts Décoratifs, Paris (invt. no. 35394, cl. 7446)

35 Hector Guimard: Plate, bronze gilt. 1909, dia. 9⅞″ (25 cm), Musée des Arts
 Décoratifs, Paris (invt. no. 18101, cl. 7390)
36 Jules Chéret: "Palais de Glace." Poster (color lithograph). 1893, 48⅞″ ×
 34¼″ (124 × 87 cm). Die Neue Sammlung, Staatliches Museum für
 angewandte Kunst, Munich. *Photo:* Sophie-Renate Gnamm, Munich
37 Henri de Toulouse-Lautrec: "Caudieux." Poster (color lithograph). 1893,
 50¾″ × 36⅝″ (129 × 93 cm), Die Neue Sammlung, Staatliches Museum für
 angewandte Kunst, Munich. *Photo:* Sophie-Renate Gnamm, Munich
38 Henri de Toulouse-Lautrec: Yvette Gilbert in "Linger, Longer, Loo."
 Drawing. *Photo:* Roger Viollet, Paris (invt. no. RV 56630)
39 Théophile Alexandre Steinlein: "Cocorico." Poster (color lithograph). 1899,
 54¾″ × 39″ (139 × 99 cm), Die Neue Sammlung, Staatliches Museum für
 angewandte Kunst, Munich. *Photo:* Sophie-Renate Gnamm, Munich
40 Victor Horta: The "Maison du Peuple" department store. 1899, Brussels.
 Photo: Bildarchiv Foto Marburg (invt. no 618055)
41 Victor Horta: Interior (hall) of the Hôtel Baron van Eetvelde. 1895/1896,
 Brussels. *Photo:* Bildarchiv Foto Marburg (invt. no. 618041)
42 Victor Horta: Door locks and handles of the Winssinger House. 1895/1896,
 Brussels. *Photo:* Bildarchiv Foto Marburg (invt. no 618052)
43 Henry van de Velde: Desk, 1899, 30″ × 102¾″ × 39⅜″ (76 × 261 × 100
 cm), Kunstgewerbemuseum, Zürich. *Photo:* Sophie-Renate Gnamm, Munich
44 Henry van de Velde: Candelabra. 1902, 23¼″ (59 cm), Nordenfjeldske
 Kunstindustrimuseum, Trondheim, Norway. *Photo:* Sophie-Renate Gnamm,
 Munich
45 Henry van de Velde: Pieces from a Meissen dinner service. Ca. 1905, cup:
 2″ (5.5 cm); large plate: dia. 10⅜″ (26.5 cm), Die Neue Sammlung,
 Staatliches Museum für angewandre Kunst, Munich. *Photo:* Sophie-Renate
 Gnamm, Munich
46 Henry van de Velde: Staircase. 1902, Karl-Ernst-Osthaus Museum (formerly
 Folkwang Museum), Hagen. *Photo:* Bildarchiv Foto Marburg (invt. no
 620393)
47 Henry van de Velde: Necklace. Gold and gems. Ca. 1900, Die Neue
 Sammlung, Staatliches Museum für angewandte Kunst, Munich. *Photo:*
 Sophie-Renate Gnamm, Munich
48 Antonio Gaucí. La Sagrada Familia ("the Cathedral of the Poor"). General
 view from the northeast. 1884–1926, Barcelona. *Photo:* Bildarchiv Foto
 Marburg (invt. no. 54498)
49 Antonio Gaudí: "Casa Milá," roof structures (chimneys). 1905–1907,
 Barcelona. *Photo:* Roger Viollet, Paris (invt. no. RV 870930)
50 Antonio Gaudí: "Casa Milá." 1905–1907, Barcelona. *Photo:* Roger Viollet,
 Paris (invt. no. RV 870931)
51 Antonio Gaudí: "Casa Milá," roof structures, 1905–1907, Barcelona. *Photo:*
 Roger Viollet, Paris (invt. no. RV 870937)
52 Charles Robert Ashbee: Silver goblet. 1902, dia. 4⅛″ (10.5 cm), private
 collection, Munich. *Photo:* Sophie-Renate Gnamm, Munich

53 Aubrey Beardsley: *The Death of Pierrot*. Wash drawing. Ca. 1900. *Photo:* Archiv Verlag M. DuMont Schauberg, Cologne

54 ARTS AND CRAFTS *(from top left to bottom right):*
 Louis Comfort Tiffany: Favrile glass. Ca. 1905, 3¾" (9.6 cm), Stuck-Villa, Munich
 Cymric, Liberty & Co.: Desk clock, 1902, 4⅞" (12.5 cm), private collection, Munich
 Gabriel Argy-Rousseau: Small vase. After 1900, 3½" (8.7 cm), private collection, Munich
 Louis Comfort Tiffany: Round vase. Ca. 1900, 4½" (11.5 cm), Stuck-Villa, Munich (cf. color plate 90)
 Cymric, Liberty & Co.: Bowl. 1902, 2½" (6.5 cm), Kenneth Barlow collection (decorative arts), Munich
 Cymric, Liberty & Co.: Covered box. 1902, 5¼" (13.2 cm), Kenneth Barlow collection (decorative arts), Munich
 Charles Muller: Vase, Ca. 1900, 13¾" (35 cm), Stuck-Villa, Munich
 Louis Comfort Tiffany: Favrile glass. Ca. 1905, 3⅞" (9.9 cm), Stuck-Villa, Munich
 Charles Schneider: Table lamp. Ca. 1900, 15⅞" (40.2 cm), Stuck-Villa, Munich
 Jan Eisenloeffel: Covered box. Ca. 1900, 7¼" (18.5 cm), Enmcke collection, Munich
 Louis Comfort Tiffany: Favrile glass. Ca. 1904, 10⅞" (27.5 cm), Stuck-Villa, Munich
 Antonin Daum: Layered glass. 1898, 18½" (47 cm), Stuck-Villa, Munich
 Photo: Sophie-Renate Gnamm, Munich (color plate)

55 Charles Rennie Mackintosh: Interior of the Willow Tearoom. 1903–1906, Glasgow. *Photo:* Courtauld Institute of Art, Glasgow (invt. no. 368/11).

56 Walter Crane: *The Horses of Neptune*. Oil on canvas. 1892, 33⅞" × 84⅝" (86 × 215 cm), Bayerische Staatsgemäldesammlungen, Neue Pinakothek, Munich.
 Photo: Joachim Blauel, Gauting bei Munich (color plate)

57 Charles Rennie Mackintosh: Glasgow School of Art. 1897–1899, Glasgow. *Photo:* Archiv des Verfassers, Munich

58 Charles Rennie Mackintosh: Chair for the Willow Tearoom. 1904, Glasgow, 41" (104 cm), Hessisches Landesmuseum, Darmstadt. *Photo:* Sophie-Renate Gnamm, Munich

59 D. H. Burnham & Co. (C. B. Atwood, collaborator): Reliance Building, 1894, Chicago. *Photo:* Archiv des Verfassers, Munich

60 Josef Hoffmann and the Wiener Werkstätte: Garden terrace and tower of the Palais Stoclet. 1905–1911, Brussels. *Photo:* Bildarchiv Foto Marburg (invt. no. 617304)

61 Josef Hoffmann and the Wiener Werkstätte: Veranda of the Palais Stoclet. 1905–1911, Brussels. *Photo:* Bildarchiv Foto Marburg (invt. no. 617306)

62 Josef Hoffmann and the Wiener Werkstätte: View of the garden and water basin on the south side of the Palais Stoclet. 1905–1911, Brussels. *Photo:* Bildarchiv Foto Marburg (invt. no. 606446)

63 Gustav Klimt: *Fulfillment*. Aquarelle and gouache, paper on wood. Ca. 1909, 75⅝″ × 46½″ (192 × 118 cm), Musée de la Ville, Strasbourg. *Photo:* Joachim Blauel, Gauting bei Munich (color plate)

64 Josef Hoffmann and the Wiener Werkstätte: Large dining room of the Palais Stoclet, wall painting by Gustav Klimt. 1905–1911, Brussels. *Photo:* Bildarchiv Foto Marburg (invt. no. 606458)

65 Josef Hoffmann: Pieces from a silver service. Ca. 1905, pot: 8″ (20.5 cm), Die Neue Sammlung, Staatliches Museum für angewandte Kunst, Munich. *Photo:* Sophie-Renate Gnamm, Munich

66 Otto Wagner: The Postal Savings Bank. 1905, Vienna. *Photo:* Archiv des Verfassers, Munich

67 Hans Schmithals: *Composition:* Mixed technique, pastel with gold. Ca. 1900, 18¾″ × 42⅞″ (47.5 × 109 cm), Stadtmuseum, Munich. *Photo:* Joachim Blauel, Gauting bei Munich

68 Hermann Obrist: *Whiplash*. Wall hanging. Ca. 1895, 47″ × 72¼″ (119.5 × 183.5 cm), Stadmuseum, Munich. *Photo:* Sophie-Renate Gnamm, Munich

69 Hermann Obrist: Model for a monument. Ca. 1895, 34⅝″ (88 cm), Kunstgewerbemuseum, Zürich. *Photo:* Sophie-Renate Gnamm, Munich

70 Carl Strathmann: *Attacking Fish*. Aquarelle, pen and ink drawing on paper. Ca. 1890, 12½″ × 17⅞″ (31.6 × 45.3 cm), Stadtmuseum, Munich. *Photo:* Joachim Blaud, Gauting bei Munich (color plate)

71 August Endell: Façade of Elvira Photographic Studio. 1896–1897, Munich. *Photo:* Stadtmuseum, Munich (invt. no. 63/12137/1, neg A. 4660)

72 Richard Riemerschmid: Pottery jug. Ca. 1900, 8⅞″ (22.5 cm), Die Neue Sammlung, Staadiches Museum für angewandte Kunst, Munich. *Photo:* Sophie-Renate Gnamm, Munich

73 Peter Behrens: Crystal goblet Ca. 1910, 7⅛″ (18.2 cm), Ehmcke collection, Munich. *Photo:* Sophie-Renate Gnamm, Munich

74 ARTS AND CRAFTS (from top left to bottom right):
 Lötz-Austria: Luster glass. Ca. 1900, 7⅞″ (20 cm), Kenneth Barlow collection (decorative arts), Munich
 Royal Saxon Porcelain Works, Meissen: Gravy boat. Ca. 1900, 4⅜″ (11 cm), Kenneth Barlow collection (decorative arts), Munich
 Engelbert Kayser: Cookie tin. 1902, 6⅞″ (17.5 cm), Kenneth Barlow collection (decorative arts), Munich
 Johann Julius Scharvogel: Small vase. Ca. 1905, 5½″ (14 cm), Kenneth Barlow collection (decorative arts), Munich
 Hans Christiansen: Drinking glasses. Ca. 1900, 5⅜″ and 4½″ (13.8 and 11.3 cm), Kenneth Barlow collection (decorative arts), Munich
 Hans Schwegerle: *Amorous Faun* (sculpture). 1902, 8″ (20.3 cm) Kenneth Barlow collection (decorative arts), Munich
 Engelbert Kayser: Candelabra. Ca. 1900, 12″ (30.5 cm), Kenneth Barlow collection (decorative arts), Munich
 Richard Riemerschmid: Pitcher. Ca. 1910, 9⅜″ (23.7 cm), Kenneth Barlow collection (decorative arts), Munich
 Michael Povolny: *Spring*. Porcelain sculpture from a series of the Seasons. 1908, 14½″ (37 cm), Kenneth Barlow collection (decorative arts), Munich. *Photo:* Sophie-Renate Gnamm, Munich (color plate)

75 Thomas Theodor Heine: "Devil." Poster, color lithograph. Ca. 1895, 38⅝″ × 26¾″ (98 × 68 cm), Die Neue Sammlung, Staatliches Museum für angewandte Kunst, Munich. *Photo:* Sophie-Renate Gnamm, Munich (color plate)

76 Bruno Paul: Caricature from *Simplicissimus.* 1901, Stadtmuseum, Munich. *Photo:* Stadtmuseum, Munich invt. no. *Simplicissimus* 1901–1902, neg. A 4669)

77 Ernst Neumann: Poster for *"The Eleven Executioners."* Lithograph. 1901–1902. 69¼″ × 50″ (176 × 127 cm), Die Neue Sammlung, Staatliches Museum für angewandte Kunst, Munich. *Photo:* Sophie-Renate Gnamm, Munich

78 Franz von Stuck: *Susanna at Her Bath.* Gouache, paper. 1913, 24¾″ × 9⅞″ (63 × 25 cm), private collection. *Photo:* Joachim Blauel, Gauting bei Munich (color plate)

79 Ludwig von Hofmann: *Idyllic Landscape with Bathers.* Oil on canvas. Ca. 1900, 25⅝″ × 37¾″ (65 × 96 cm), private collection. *Photo:* Joachim Blauel, Gauting bei Munich (color plate)

80 Josef Maria Olbrich: The Wedding Tower. 1901–1908, Mathildenhöhe, Darmstadt. *Photo:* Bildarchiv Foto Marburg (invt. no. 620309)

81 Josef Maria Olbrich: The artist's house. 1901, Mathildenhöhe, Darmstadt. *Photo:* Bildarchiv Foto Marburg (invt. no. 620304)

82 Josef Maria Olbrich: Soup spoon. 1901, 7″ (18 cm), Die Neue Sammlung, Staatliches Museum für angewandte Kunst, Munich. *Photo:* Sophie-Renate Gnamm, Munich

83 Peter Behrens: Entrance to the artist's house. 1901, Mathildenhöhe, Darmstadt. *Photo:* Joachim Blauel, Gauting bei Munich

84 Jan Eisenloeffel: Brass utensils. Ca. 1910, pot: 7¾″ (19.6 cm), Die Neue Sammlung, Staatliches Museum für angewandte Kunst, Munich. *Photo:* Sophie-Renate Gnamm, Munich

85 Edvard Munch: *The Shriek.* Lithograph (from the painting of 1893). 1895, 13¾″ × 9⅞″ (35 × 25 cm), Folkwang Museum, Essen. *Photo:* Bildarchiv Foto Marburg (invt. no. Z 16797)

86 Jan Toorop: *The Three Brides.* Chalk on paper. 1893, 30¾″ × 38⅝″ (78 × 98 cm), Rijksmuseum (Kröller-Müller Stichting), Otterlo. *Photo:* Joachim Blauel, Gauting bei Munich (color plate)

87 Georges Minne: *Kneeling Youth.* Marble sculpture. 1898–1906, 32⅝″ (83 cm), Kunsthistorisches Museum, Vienna. *Photo:* Sophie-Renate Gnamm, Munich

88 Louis Comfort Tiffany: Favrile glass. Ca. 1900, 13″ (33 cm), private collection, Starnberg. *Photo:* Sophie-Renate Gnamm, Munich (color plate)

89 Emile Gallé: Decorative glass. Ca. 1900, 17⅞″ (45.4 cm), Stuck-Villa, Munich. *Photo:* Sophie-Renate Gnamm, Munich (color plate)

90 Louis Comfort Tiffany: Round vase. Ca. 1900, 4½″ (11.5 cm), Stuck-Villa, Munich. *Photo:* Sophie-Renate Gnamm, Munich (color plate)

91 Louis Comfort Tiffany: Lamp. Ca. 1900, 25¾″ (65.5 cm), Stuck-Villa, Munich. *Photo:* Sophie-Renate Gnamm, Munich (color plate)

92 Karl Koepping: Ornamental glass. Ca. 1900, 8⅞″ (22.5 cm), private collection, Starnberg. *Photo:* Sophie-Renate Gnamm, Munich (color plate)

93 Josef Hoffmann: Four ornamental glasses. Ca. 1905, ca. 5⅞″ (15 cm), Kunstgewerbemuseum, Nuremberg. *Photo:* Sophie-Renate Gnamm, Munich

Photographic Credits

Cologne, Archiv Verlag M. DuMont Schauberg: fig. 53
Gauting near Munich, Joachim Blauel: figs. 21, 22, 56, 63, 67, 70, 78, 79, 83, 86
Glasgow, Courtauld Institute of Art: fig. 55
Marburg, Bildarchiv Foto Marburg: figs. 31, 40, 41, 42, 46, 48, 60, 61, 62, 64 80, 81, 85
Munich, Archiv des Verfassers: figs. 57, 59, 66
—, Deutsches Museum: fig. 4
—, Sophie-Renate Gnamm: figs. 7, 15, 16, 18, 19, 26, 30, 36, 37, 39, 43, 44, 45, 47, 52, 54, 58, 65, 68, 69, 72, 73, 74, 75, 77, 82, 84, 87, 88, 89, 90, 91, 92, 93
—, Stadtmuseum: figs. 71, 76
Paris, Chevojon: fig. 5
—, Musée des Arts Décoratifs: figs. 9, 10, 11, 12, 13, 14, 17, 20, 23, 24, 25, 27, 28, 29, 34, 35
—, Roger Viollet: figs. 1, 2, 3, 6, 8, 32, 33, 38, 49, 50, 51

Index

Page references for illustrations are printed in italic type

America, 41, 105–106, 164
Amourous Faun (Schwegerle), *127*
Amsterdam Stock Exchange, 141
André, Charles and Emile, 45
Applied art, 14, 93
Arab art and architecture, 87
Arabesque, 104
Architectura et Amicitia, Netherlands, 41
Architecture, 14–15, 19–20, 25, 28. *See also* names of architects
Argy-Rousseau, Gabriel, *97*
Art décoratif, L' (periodical), 41
Art et Décoration (periodical), 41
Art Journal, The, 93
Art naturiste, 22, 45
Arts and Crafts Exhibition Society, England, 92–93
Arts and Crafts Movement, England, 93, 95
Ashbee, Charles Robert, 38, 57, 92, 93, 94, 107
Atelier Elvira, Munich, *124,* 125–126
Attacking Fish (Strathmann), 122–123
Austria, 41, 106–118, 162

Barcelona, Spain, 87–91
Baroque art, 23
Baudelaire, Charles, 46, 98, 150
Beardsley, Aubrey, 38, *95,* 95–96, 98, 106
Behrens, Peter, 40, *125,* 128, 130, 139, *139,* 163
Belgium, 38, 76–86, 148
Berlage, Hendrick Petrus, 140–141
Bing, Samuel, 39, 143
Böcklin, Arnold, 146
Bode, Wilhelm von, 40
Bodenhausen, Eberhard von, 28, 40
Bonnard, Pierre, 39, 147
Book illustration, 14, 96, 98
Bourgeois, 62, *63*
Bradley, William H., 41, *69*

Brussels, Belgium, 38, 76–86; Palais Stoclet, 108, *109,* 110–111, *110–111, 113,* 114–115
Burnham, D. H., *105,* 106

Calligraphy. *See* Typography and lettering
Carriès, Jean, *64,* 65
Carson, Pirie, Scott & Co., Chicago, 105
Cartouche, 23
Casa Milá, Barcelona, *88, 89,* 91, *91*
Castel Béranger, Paris, *71,* 72
Cast iron, 15
Catalonia, Spain, 87
Caudieux (Toulouse-Lautrec), *73,* 76
Celtic art, 105
Century Guild, England, 39, 93, 95
Ceramics, 62, *64,* 65, *66–67, 83,* 84. *See also* Glass objects; Porcelain; Pottery
Cercle des Vingt, Brussels, 38
Chamber Theater, Munich, 128
Chap Book (periodical), 41
Chaplet, Ernest, 65
Charpentier, Alexandre, 49, *50*
Chéret, Jules, *73,* 76
Chicago, Illinois, 105–106
Chinese glass art, 155
Christiansen, Hans, *127*
"Cocorico" (Steinlein), *75*
Color, 20–21, 36, 103
Combed glass, 159, 161, 163
Communal workshops, 38; Darmstadt, 135–136
Composition (Schmithals), *119*
Crane, Walter, 93, 98, *100–101*
Crystal Palace, London, 15, *16–17*

Dammouse, Albert, 54, *57, 64,* 65, 164
Dance, 67–69, 71
Darmstadt, Germany, 111, 135–139
Daum, Antonin, *43,* 44, 53, *57, 97,* 154
Death of Pierrot, The (Beardsley), 95
Decoeur, Emile, *64,* 65
Décorchement, François, 54, *57,* 164
Dekorative Kunst, Die (periodical), 41

Delaherche, Auguste, *64,* 65
Denis, Maurice, 147
Devil (Heine), *129*
Dial, The (periodical), 39
Dictionnaire raisonné de l'architecture française (Viollet-le-Duc), 77
Douai, France, shop window, *70*
Dresdner Werkstätte für Handwerkskunst, 41

Eckmann, Otto, 29, 128, 131
Ehrenfeld glassworks, Germany, 163
Eiffel Tower, Paris, 15, *18*
Eisenloeffel, Jan, *97,* 141, *141,* 142
Eleven, The, Berlin, 135
Eleven Executioners, The (Neumann), *131*
Embroidery, 124–125
Endell, August, *124,* 125–126, 128
Engelhard, Christian Valdemar, *64*
England, 15, 28, 39, 92–98, 155, 158
Ernst Ludwig, Grand Duke of Hessen, 28, 135–136
Eroticism, 23, 26
Etched glass, 151, 154, 155, 158
Expressionist Architecture (Pehnt), 90

Favrile glass, *43, 97, 152,* 159, 161, 164
Female symbolism, 22–23, 59
Feure, Georges de, 65, *66, 67*
Finland, 142–143
Flaischlen, Caesar, 40
Fledermaus, Vienna, 108
Flower symbolism, 22, 53, 56, 94–95, 150
France, 9–25, 28, 38–39, 41–76, 146, 150, 154-155, 158, 164
Fulfillment (Klimt), *112,* 114
Fuller, Loie, 65, 67–68, *68*
Furniture, 24–26, 47, *48–51,* 49–53, *53–55, 72,* 73, 81, 84, 92, 101, *103,* 104, 128, 130

Gaillard, Eugène, 39, *48,* 49
Gallé, Emile, 29, 39, 42, *43,* 44–45, 47, 51–53, *53–55, 57, 64,* 87, 150–151, *153,* 154, 158
Gaudí, Antonio, *86,* 87–91, *88, 89, 91*
Gauguin, Paul, 26, 38, 147–148

Gaul, Richard, 40
Germany, 28, 39–41, 119–139, 148, 155, 163–164
Gide, André, 37
Glasgow, Scotland, 98–104
Glasgow School of Art, Scotland, *102,* 104
Glass building material, 15, 19–20, 77, 79–80
Glass marquetry. *See* Inlaid glass
Glass objects, 20, 24, *43,* 44, 51, 53–54, *57, 58, 97, 125, 127,*
 149–164, *152, 153, 156, 157, 160, 162*
Gogh, Vincent van, 38, 147–148
Gothic architecture, Spain, 87
Grammar of Ornament (Jones), 105
Graphics, 21, 24, 59, 96, 98, 106, 128
Grasset, Eugène, 58–59, *61, 62*
Guild School of Handicraft, England, 92
Guimard, Hector, 9, *10–13,* 12–15, 19–25, *19,* 39, *71,* 72, *72, 73,* 76

Hartleben, Otto Erich, 40
Haus Winssinger, Brussels, 80, *80*
Heine, Thomas Theodore, 40, *129,* 133
Hessen, Grand Duke of. *See* Ernst Ludwig
Hirth, Paul, 40
Hobby Horse (periodical), 39
Hodler, Ferdinand, 148
Hoentschel, Georges, 46, *48,* 49
Hoffmann, Josef, 41, 107–108, *109,* 110, *110, 111, 113, 114,*
 115–116, *162,* 163
Hofmann, Ludwig von, 40, *133,* 134–135
Hohlwein, Ludwig, 133
Hölzel, Adolf, 133
Horses of Neptune, The (Crane), 98, *100-101*
Horta, Victor, 29, 38, 76–77, *77, 78,* 79–80, *80*
Hôtel Baron van Eetvelde, Brussels, *78,* 80
Hugo, Victor, 150

Idyllic Landscape with Bathers (von Hofmann), *133,* 135
Inlaid furniture, 53
Inlaid glass, 154
Interior decoration, 25–26, 41, 47, 103, 107, 111, 128
International art nouveau, 36, 81
Iron building material, 15, 19, 77, 79

Italy, 94, 155

Japanese art, 24–25, 45, 62, 65, 94, 96, 98, 100, 128, 159
Jeanneney, Paul, *64,* 65
Jewelry, 14, 20, 54–56, 58, *59, 60, 63, 85,* 85–86
Jolly, Henry, 62, *66*
Jones, Owen, 105
Jugend (periodical), 40

Karl-Ernst-Osthaus-Museum, Hagen, Germany, *83,* 84
Kayser, Engelbert, *127*
Kessler, Count Harry, 28, 40, 84
Khnopff, Fernand, 38, 148
Klimt, Gustav, 41, 107–108, *112, 113*
Klinger, Max, 147
Kneeling Youth (Minne), *147*
Koepping, Karl, 40, *160,* 163
Kok, Juriaan, *57,* 140
Kokoshka, Oskar, 114–115
Kunst und Handwerk (periodical), 41
Kunst und Industrie (periodical), 41

Lachenal, Edmond, *64,* 65
Laeuger, Max, 131
Lalique, René, 54–56, 58, *59*
Larche, Raoul, 65, 67, *68*
Lavirotte, Jules, 46, *47*
Layered glass, *43, 57, 97,* 151, 154, 159
Leistikow, Walter, 40, 148
Lettering. *See* Typography and lettering
Leveillé, Ernest, *43*
Liberty, Arthur Lathenby, 94
Liberty (English firm), 94
Libre Esthétique, La, Brussels, 38
Lichtwark, Alfred, 40
Line, importance of, 24–25, 94, 96, 104, 106, 145
"Linger, Longer, Loo" (Toulouse-Lautrec), *74*
London, England, 92–98; Crystal Palace, 15, *16–17*
Loos, Adolf, 118
Lötz glass, *127,* 162
Luster glass, *127,* 159, 161–162

McDonald sisters, 98, 101–103
Mackintosh, Charles Rennie, 98, *99,* 100–104, *102, 103,* 107
Mackmurdo, Arthur, 93, 95
McNair, Herbert, 98
Maison du Peuple, Brussels, 76–77, *77,* 79
Majorelle, Louis, 39, 44–46, 50–51, *51, 52,* 73, 128
Mallarmé, Stephane, 150
Martin, Camille, 45
Marx, Roger, 45
Maus, Octave, 38
Meier-Graefe, Julius, 8, 40, 143
Meissen porcelain, *83,* 84, *127*
Mendelsohn, Erich, 136
Métro entrances, Paris, 9, *10–13,* 14–15, 19
Minne, Georges, 38, *147,* 148
Moderne Architektur (Wagner), 116
Modersohn-Becker, Paula, 148
Moll, Karl, 108
Moore, Bernhard, *64*
Moorish art and architecture, 87
Moreau, Gustave, 146
Morris, Marshall & Faulkner, 92
Morris, William, 27–28, 33, 35, 38–39, 92–94, 96, 105, 115, 140, 158
Moser, Koloman, 41, *43,* 107–108, 115
Mucha, Alphonse, 49, *49,* 58, *60,* 62
Muller, Charles, *97*
Munch, Edvard, 39, *142,* 143
Munich, Germany, 119–135
Museum for Art and Industry, Austria, 106
Museum for Arts and Crafts, Austria, 107
Music, influence of, 69, 71, 124

Nabis, 39, 147–148
Nancy, France, 38, 41–45, 154, 158
Nature romanticism, 119
Netherlands, 41, 139–142, 155
Neumann, Ernst, *131*
New Dachau, Munich, 133, 148
Nieuwe Kunst (periodical), 41
Northwood, John, 158
Norway, 143

Nudes, 22–23

Obrist, Hermann, 120–121, *120, 121,* 124–126
Olbrich, Josef Maria, 106, 116, *134,* 136, *137,* 138–139, *138*
Opalescent glass, 159
Orlik, Emil, 108
Ornament und Verbrechen (Loos), 118
Osthaus, Karl Ernst, 28–29

Painting, 14, 24, 144–148. *See also* names of painters
"Palais de Glace" (Chéret), *73*
Palais Stoclet, Brussels, 108, *109,* 110–111, *110, 111, 113,*
 114–115
Pallme-König, Joseph, *43,* 163
Pan (periodical), 39–40
Pankok, Bernhard, 126, 128
Papillon glass, 162
Paris, France, 46–76; Eiffel Tower, 15, *18;* métro entrances, 9,
 10–11, 12–15, *12, 13,* 19–25, *19*
Paté-decor, 65
Paul, Bruno, 40, 130, *130*
Paxton, Joseph, *16–17*
Pehnt, Wolfgang, 90
Periodicals, 39–41
Philosophy, Law, and Medicine (Klimt), 114
Physiognomic symbolism, 140
Plant motifs, 22, 42, 45–46, 56, 65, 94–95
Plastic ornament, 65, 67
Porcelain, *57,* 84, *127*
Poschinger, Ferdinand von, 163
Postal Savings Bank, Vienna, 116, *117*
Posters, *73, 75,* 76, *129,* 131, *131,* 133
Pottery, *125,* 128
Povolny, Michael, *127*
Pre-Raphaelites, 100–101, 146
Printing, 14
Prouvé, Victor, 44–45
Pukersdorf Sanatorium, Vienna, 108
Putz, Leo, 131
Puvis de Chavannes, Pierre, 95, 146

Rathenau, Walter, 28
Redon, Odilon, 38, 148
Reliance Building, Chicago, *105*
Renaissance style, 106
Revue Blanche (periodical), 39
Richardson, Benjamin, 158
Riemerschmid, 33, *125, 127,* 128
Rococo art, 45
Roller, Alfred, 108
Roth, Alfred, 31
Rousseau, Eugène, 54, *58*
Roussel, Paul, 147
Royal Saxon Porcelain Works, Meissen, 84, *127*
Ruchet, Berthe, 124
Ruskin, John, 33, 115, 118
Ruskin pottery, *64*

Saarinen, Eliel, 142
Sagrada Familia, La, Barcelona, *86,* 88, 90
Scharvogel, Johann Julius, *127,* 131
Schmalenbach, 146
Schmithals, Hans, *119,* 125
Schmutzler, Robert, 51
Schneider, Charles, *97*
Scholle, Die, Munich, 131, 148
Schwegerle, Hans, *127*
Scotland, 98–104
Script. *See* Typography and lettering
Sculpture, 14, 144–148. *See also* names of sculptors
Secession, Munich, 119
Secession, Vienna, 41, 106–108, 116
Seidlitz, Waldemar von, 40
Sembach, Klaus-Jürgen, 31–37
Sentimental naturalism, 147–148
Serpentine Dance, The (Bradley), *69,* 106
Serusier, Denis Paul, 147
Sexual symbols, 23
Shop windows, *70,* 71–72
Shriek, The (Munch), *142,* 143
Silver objects, *57, 93,* 94, *114,* 115, 142
Simplicissimus (periodical), 40

Social reform, 27, 29
Space, decoration of, 25
Spain, 87–91, 155
Spring (Povolny), *127*
Steinlein, Théophile Alexandre, *75*, 76
Stile Liberty, Lo, 94
Stoclet, Adolphe, 110
Strathmann, Carl, *122–123*, 125
Stuck, Franz von, *132*, 133–134
Studio, The (periodical), 39
Style métro, 72
Sullivan, Louis, 105
Susanna at Her Bath (von Stuck), *132*
Symbolist movements, 21, 38, 96, 98, 104
Symons, Arthur, 98
Syntheticism, 147

Thesmar, Fernand, *57*
Thorn-Prikker, Jan, 38, 140
Three Brides, The (Toorop), 140, *145*
Tiffany, Louis Comfort, 29, 39, *43*, *97*, 105–106, *152*, *156*, *157*, 159, 161–162
Toorop, Jan, 38, 140, *145*
Toulouse-Lautrec, Henri de, 39, 41, *73*, *74*, 76, 95, 106
Träumenden Knaben, Die (Kokoshka), 115
Treasury of Japanese Forms (Bing), 39
Typography and lettering, 21–22, 40, 131

Die Schönheit (Endell), 126
United Workshops for Arts and Crafts, Munich, 128, 130

Eugene, 44
Vallotton, Félix, 39, 147
van Gogh, Vincent, 38, 147–148
Van nu en straks (periodical), 41
Vegetable motifs. *See* Plant motifs
Velde, Henry van de, 27–39, 81, *81*, *82*, *83*, 84–86, *85*, 103
Venetian glass, 155
Vereinigte Werkstätten für Kunst und Handwerk, Munich, 41
Verlaine, Paul, 147
Verlaine, Paul, 40

Ver sacrum (periodical), 41
Vever, Henry, 58–59, *63*
Vienna, Austria, 106–118
Viollet-le-Duc, Eugène-Emanuel, 77
Voysey, Charles Francis, 94–95
Vuillard, Edouard, 39–40, 147

Wagner, Otto, 106, 108, 116, *117,* 118, 136
Waldglas, 155
Wallpapers, 59, 62, *63*
Wärndorfer, Fritz, 107
Water, 46
Webb, Philip, 158
Wedding Tower, Darmstadt, *134,* 136
Werkbund, 34
Whiplash (Obrist), *120,* 124–125
Wiener, René, 45
Wiener-Werkstätte-Produktiv-Gemeinschaft von Kunsthandwer-
 ken in Wien, 107–108, *109,* 110, *110, 111, 113,* 115, 118
Willow Tearoom, Glasgow, *99, 103*
World's Fair (1900), 42, 55

Yachting style, 39
Yellow Book, The (yearbook), 39

Zitzmann, Josef, 163
Zweckmässigoder Phantasievoll (Obrist), 120–121